It's Personal
The Art of Robert Beck

Exhibition and catalogue prepared by
David Leopold

James A. Michener Art Museum
Doylestown, Pennsylvania

This publication accompanies the
James A. Michener Art Museum exhibition
It's Personal: The Art of Robert Beck
Fred Beans Gallery
July 31, 2021–January 2, 2022

It's Personal: The Art of Robert Beck and its attendant
publications are generously supported by Amy
Stewart Powell, Elise and John Rupley, and Barbara
and David Stoller. Additional support is provided
by Lucinda Avery Ayers, Rago Auctions, Jean Wilson
and John Roberts, Joe and Judy Franlin, and
Jacqui and David Griffith.

Library of Congress Control Number: 2021938225
Softcover: 978-1-879636-02-6
Hardcover: 978-1-879636-03-3

Design: J. Geddis
Editor: Constance Rosenblum
Proofreader: Paula Brisco
Printed and bound by Brilliant Graphics

Page 4: photograph of Robert Beck
by Bob Krist

All archival material and photographs are courtesy
of the artist.

Front cover: *Dory* (detail)
Oil on panel
24 x 48 in., 2015
Private Collection

Opposite: *Jack*
Oil on panel
8 x 6 in., 2016
Collection of Doreen Wright

Dimensions of works are cited with height
preceding width.

For Jack

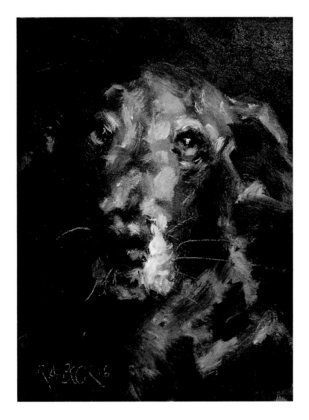

Contents

Foreword

Robert Beck is an artist who is deeply connected to the New Hope–Lambertville community. As word of this exhibition and catalogue began to circulate, I frequently heard from Michener visitors and supporters: "Oh, I know Bob!" "I have one of his paintings!" "I knew him when he was just starting out!" "He painted for one of our fundraisers!" Just as Beck is committed to the community and to painting its inhabitants and events during challenging and celebratory moments, community members in turn have watched him evolve and grow as an artist, and they take pride in his success. This is the case in Bucks County as well as in other locales where Beck has embedded himself, including New York City and the fishing village of Jonesport, Maine. Beck does not simply paint what he sees, he paints to understand, interpret, and reveal. Part of that process is getting to know his subjects and the places they call home.

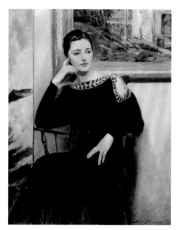

As David Leopold notes in his catalogue essay, Beck's paintings build upon the rich artistic tradition of the Bucks County region. Much like the Pennsylvania Impressionists, Beck embraces an expressive handling of paint and he paints from life, although he also works from memory in his studio. He occasionally responds to the region's historical paintings directly. In Beck's *Sunday Morning*, a woman dressed in a purple and blue kimono is seated in an upholstered barrel-back chair. She gazes out of frame, her face in sharp profile, illuminated by the bright window behind her. Her right hand languidly curves over the chair's back. Beck admits that he had a couple paintings in the Michener Art Museum's collection in mind when composing this scene: Ben Solowey's *Rae Seated* (1935), in which Solowey's beloved wife, Rae, poses in a striking green dress, and Daniel Garber's *Studio Wall* (1914), a work that has been on loan to the Michener from Garber's family for nearly three decades. First shown at the Michener in a group exhibition in 1999, *Sunday Morning* is now part of the museum's permanent collection, where it shares space with the paintings that inspired it, drawing a clear line from the region's artistic past to the present day.

The James A. Michener Art Museum is honored to present this exhibition of Beck's paintings and share his work with our visitors. Through close collaboration with the artist and his innate storytelling ability, curator David Leopold deftly articulates Beck's evolution from a graphic designer at a local packaging firm to a celebrated, widely exhibited artist in this beautiful catalogue. We are grateful for his dedication and enthusiasm as he researched and developed this comprehensive exhibition. Thanks are also due to Michener staff who helped bring this project to fruition and provided logistical support along the way.

As the exhibition and catalogue title suggests, Beck's approach to his subjects is personal. "Painting is in one regard an act of intimacy," he explains. Beck's subjective vision, however, is highly relatable and familiar to many of us. In his paintings, we might recognize a landmark, a face, a gesture, the bustle of a crowded restaurant, or the spray of a salty ocean breeze. Beck is adept at capturing not just the look but the feeling or impression of a moment. His paintings convey a strong sense of community and belonging that resonates with many of us, especially in light of the challenges of the past year, and help us imagine better days ahead.

Laura Turner Igoe
Chief Curator
James A. Michener Art Museum

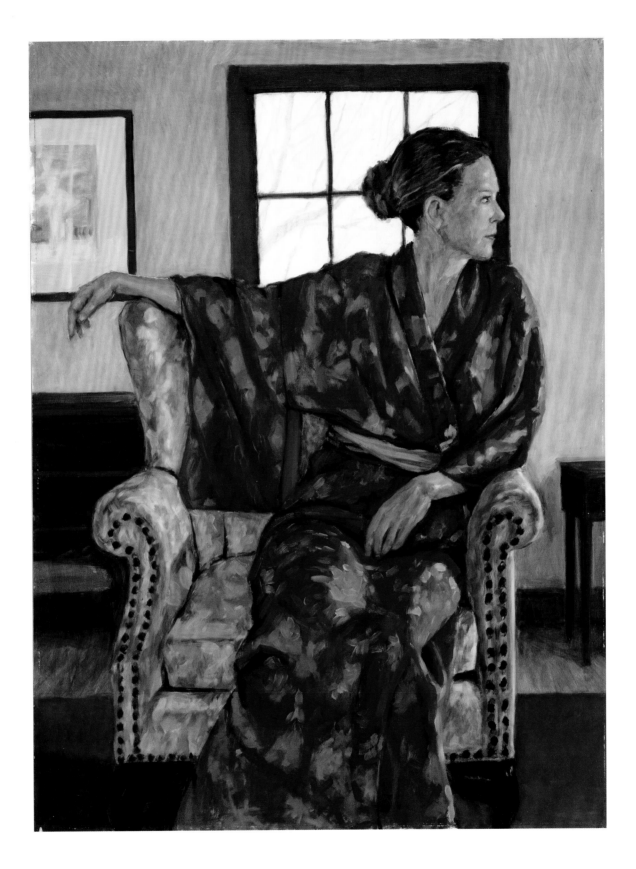

opposite, top

Rae Seated (Green Dress)
Ben Solowey (1900–1978)
Oil on canvas
45 x 36 in., 1935
Collection of the James A.
Michener Art Museum
Museum purchase funded by
Anne and Joseph Gardocki

opposite, bottom

The Studio Wall
Daniel Garber (1880–1958)
Oil on canvas
56 x 52 in., 1914
Private Collection

Sunday Morning
Oil on panel
24 x 18 in., 1996
Collection of the James A.
Michener Art Museum

At This Moment

My most recent painting (as of this writing) is of my dog, Jack, sitting in the yard outside my studio during a snowstorm in February of 2021. There are a few other images I have in mind to paint, but right now they are just shadows, waiting for illumination.

This catalogue casts its gaze over my career and my life, examining the artistic continuum as well as individual building blocks. The curator of this retrospective, David Leopold, has the benefit of having a live artist to answer questions and connect dots for the story, but as that artist, I live and work at the leading edge of the accounting. Much of my past seems like another lifetime. My quotes and observations reflect what my understanding was when I said them. They still hold true, but they were a product of a certain time. It has been a Lewis and Clark exploration, keeping me amazed at being in a place I hadn't imagined and not knowing what's around the next corner, not to mention that mountain up ahead. Hindsight is perspective, and every new day adds clarity.

I've lived during a period of vast social change and, as a white, American, middle-class male, tremendous freedoms. I was born in an age of Norman Rockwell, Andrew Wyeth, and Abstract Expressionism, and I swung with the changing fashions of art before understanding the lies that popularity tells. I was drawn to the narratives of Thomas Hart Benton, Edward Hopper, and Winslow Homer, and came to appreciate George Bellows later in my career. These artists painted the world I occupy, and they spoke my language. When I decided to pursue painting as a forty-year-old, I had the benefit of having seen how life unfolds and learning what I could influence and what I couldn't. Things wouldn't have been the same if I had started earlier.

Many factors got me to this point in time. The post-war era, my family environment, places I've lived, and the personal associations I've made along the way. My father,

who had many practical skills, made beautiful drawings for pleasure, and I wanted to emulate him. I was scribbling at a very early age. A decade spent as a graphic artist trained my eye and taught me discipline. The venerable Pennsylvania Academy of the Fine Arts in Philadelphia immersed me in working from life, establishing a link between the moment—my immediate awareness—and that visual language I'd been crafting since before I could read.

There were many significant moments throughout my career, involving places, people, experiences, and those things an artist learns by continuously chasing new and different ideas. Discoveries, approaches, mistakes, solutions—all became part of a method. A lexicon. My wife has been my fuel.

The more important part of this growth and refinement can be (inadequately) described as developing a "process"—the combination of what captures my attention, why I decide to paint and write about it, the preparation, and the execution. That entire practice is subject to self-scrutiny and modification every time I go through it, and I search for truth and resonance right up to the last brushstroke with no set map showing me how to get where I'm going. Taking chances is part of every painting. New questions are built on old answers.

Over the years, I learned to suspect subjects that "looked like paintings" and to rely on my own response to personal encounters. Interest is just a starting point, a tap on the shoulder. Caring about something is the key—discovering and describing what about it matters to me. When I understand the what, I'm faced with the why. Answering that question helps me grow as a person as well as an artist.

Much of communication involves contrast and metaphor. Complex ideas are best explained by relating them to something already understood. I have learned to allow myself to paint what my experience made me think about, where it took me, trusting that the initial inspiration will inform the result in a revealing way. It's okay for my aim to wander. The goal is to arrive at something meaningful, even if it's not what I foresaw, and even if I arrive there by chance. The whole process is an expedition, and the finished painting is merely where I land at the end of it.

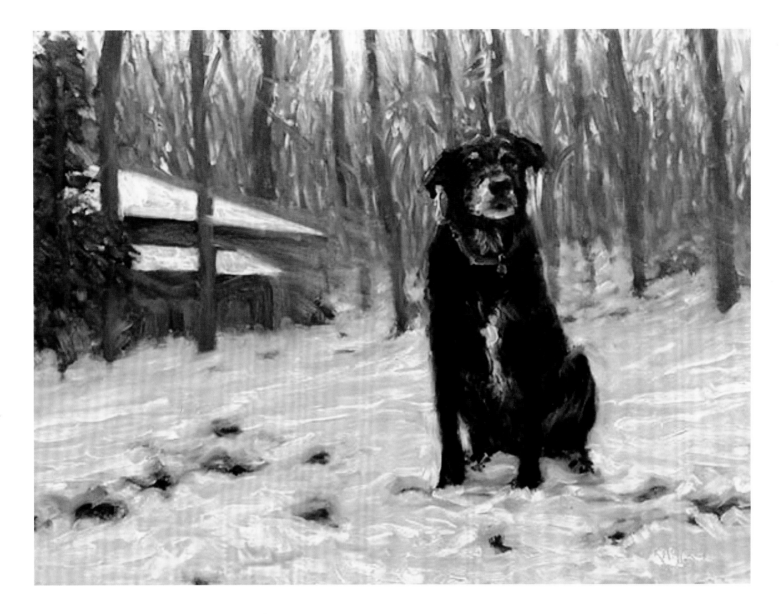

Much of my present attention is toward environments and emotional responses. Seeing Jack in the snow seemed so real. I stopped shoveling. It was gray and biting cold but quiet. My nose was running, and I wiped it on the back of my glove. I saw my studio in the trees—this place I love. Jack was waiting for what we might do next. That moment mattered deeply to me. It was one of those taps on the shoulder that, when I pause to listen, whisper my name.

Robert Beck
Solebury Studio
February 20, 2021

Jack in Snow
Oil on panel
12 x 16 in., 2021
Collection of the artist

Introduction

When I started my research on Robert Beck, like many I was best acquainted with his documentary paintings, as he refers to his paintings done on-site in one go. I marveled at how he could create in the heat of the moment such compelling images that seem to rise above any topical value they might have. How did he paint these pieces? Why did he paint these pieces? These are questions a curator frequently faces, and with Beck I have had both the pleasure of hearing the answers from the artist himself and my own experience of seeing the paintings in exhibitions over the years when the connection to "why?" was much more direct. Now having seen so many of his works, and having heard so many stories, my view of them has been enriched.

Of course, they are valuable visual documents of the last thirty-plus years, recording his world much like the Pennsylvania Impressionists recorded theirs. Beck, however, has not spent all of his time in nature painting the changing seasons but in a world that you and I live in too. We can identify with the storefronts, street corners, bars, restaurants, carnivals, basketball games, funeral homes, parades, and so much more that we see in Beck's paintings. His relationship to the New Hope–Lambertville area reminds me of Eugène Atget and Paris, in that Beck has created what seems like an almost encyclopedic, idiosyncratic lived portrait of the area at the turn of the twenty-first century. Over more than a decade, Beck has done the same for the fishing and lobstering town of Jonesport, Maine.

Beck's compositions are infused with emotions, memories, and experiences that he transmutes through his deft handling of paint to make the scene even more vivid to the viewer. He mixes Impressionist brushwork with a Realist's eye for the telling detail to create paintings that capture both the look and the personality of his subject. His interest in the character of what he is painting—where each scene, no matter how common at first glance, is given an individuality that in his best work demands a viewer's attention—is coupled with an expressive palette, so that his relatively intimately sized paintings call to mind an American Romanticism. The delicate balancing of these conflicting tendencies produces a pleasurable tension that gives Beck's art its distinctive beauty.

Many of these works are parts of different series that attempt to capture the soul of its topic, whether it be a town, a time of day, a journey, or a way of life. His series are not portraits of his subject but rather a tapestry of its features. These extended engagements allow him to use a variety of techniques and styles so that the series is as multifaceted as the topic it covers. To see some or all of a series gives the viewer a sense of discovery that Beck may have had in looking for the scenes he wanted to paint. In this catalogue I have included "portfolios" from five of his series, plus an extended selection of his Maine work.

If he created only documentary paintings, his work would be worthy of a museum retrospective, particularly at the James A. Michener Art Museum, because his paintings have a direct antecedent in style to those of Edward Redfield, Robert Spencer, and George Sotter, to name a few of the Pennsylvania Impressionists. Redfield was famous for painting his canvases on-site over a day. Beck functions the same way for his "plein air" work. Beck, like Spencer, enjoys a natural setting and landscapes with buildings, but Beck goes beyond mills and workers to bring us people and places of all kinds. Sotter loved a nighttime landscape, and Beck favors those as well, but beginning with a series he painted in 1998 and 1999, he took the nocturne concept and turned it inside out, and has continued to do so. That is what makes Beck different from most of his contemporaries in the area. He advances the tradition instead of imitating it.

Yet his documentary paintings are only one part of his career. His studio output, freed from the time clock that his on-site work demands or the reality it captures, exposes a much more nuanced view of the artist. Here his Realism comes into full flower, and he is far more deliberate in refining his compositions, even if they come completely from his own mind. *Dory*, a painting of a small boat coming across

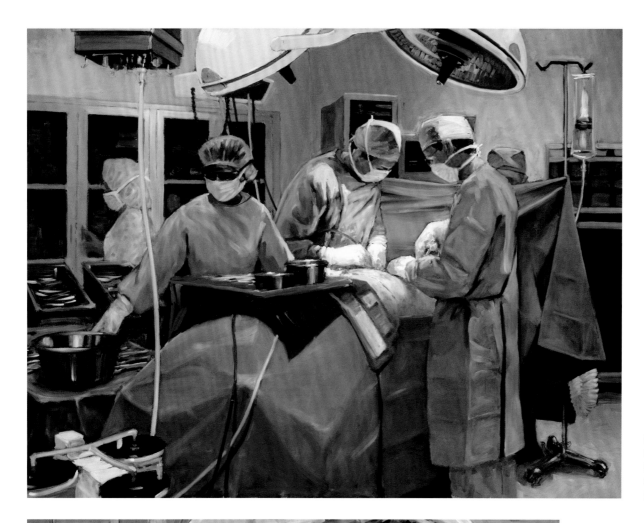

**Drs. Ruenes and Flashner
in Surgery (studio)**
Oil on panel
30 x 40 in., 2007
Private Collection

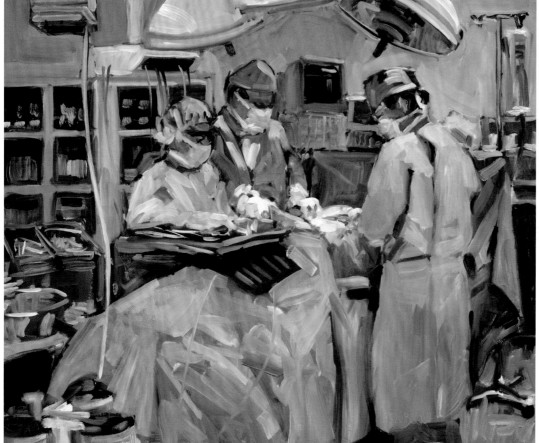

**Drs. Ruenes and Flashner
in Surgery (live)**
Oil on panel
16 x 20 in., 2007
Collection of Cindy and
Al Ruenes

a whale mid-spout at night, may not be drawn from Beck's actual experience, but after viewing the painting—with its masterful handling of light from the oily wet sheen of the whale to the shadows we first encounter when looking at the boat—I defy anyone to not come away feeling that this is what it must be like. Beck does not achieve that type of verisimilitude by layering on detail but rather by imagining what a viewer would take in in the same situation and including only those essential details. In his studio paintings, he almost conceals the evidence of his brush, so with the painting's tranquil facade the viewer really feels the spray of the whale's spout.

In another of his studio paintings, *Sheep's Clothing*, a sheep wearing a coat to keep it clean before judging at the Middletown Grange Fair shows a distinct personality even though most of the animal is covered. The cocked hood, the ewe's eye staring directly at the viewer, and a hint of her legs tells us all we need to know about her. You can feel the dull luster of the stone wall and even see the slats of the barn behind her, but nothing interferes with the viewer making acquaintance with the animal herself.

A head-to-head comparison of Beck's "live" and studio paintings can be had in his images of an operation in a hospital. The painting done on the spot—during an actual operation—has the moment-to-moment tension of the actual procedure. The brushwork appears frenetic, but all the important information is there. It feels like a George Bellows painting of a boxing match: quick, short strokes that capture the intensity of the moment. The studio distillation of the event is much calmer, more thoughtful with less drama, yet it still conveys the quiet intensity the doctors have while performing their mission. In the studio painting of the operating room, Beck adjusts the lighting so not only does it direct the eye to look at the action on the table first, but the light also plays on the various fabrics throughout the picture in a way that should make any serious still-life painter green with envy.

Beck's studio work, separated from the bravura style of his plein air work, reveals the seriousness of his painting. His technique is solid, and his ability to manipulate even

strong graphic elements, such as contrast in his nocturnes, into something more explicitly designed often edges his images away from Realism and toward the poetic suggestiveness of Symbolism. There is no mistaking one of Beck's paintings for that of another artist. The studio work, with its quiet balance at its core, seems like history in the making. While it is his plein air work that has justly earned him a fair amount of press and reputation, it is his studio paintings that I think will be viewed by future generations as examples of some of the best work to come from this region.

A retrospective of a living artist is almost always incomplete. The artist continues to work, and a curator is faced with a tough question: Where does one stop and look back? This decision is made more difficult when Robert Beck, the artist in question, is still painting at a remarkably high level. In this catalogue I aim to explain how he came to achieve both styles of paintings, and a host of other accomplishments. I frequently employ Beck's own words to give the reader a sense of what he was thinking as he painted selected works or how he saw his career over the past thirty years. The story of his evolution as an artist and as a member of the region's art community is as compelling as many of his paintings. This catalogue does not include every great story or even every great painting. Beck has had too many adventures and a pretty high batting average when it comes to his work to include everything. What it does have, for the first time, is the most documented history of his career, drawing on countless articles, interviews, and, of course, the paintings themselves that speak, perhaps, more eloquently than any words I can write.

David Leopold
Bedminster, Pennsylvania
March 25, 2021

ROBERT BECK

Timeline

Robert Beck Timeline

1950

Born October 17 at Holy Name Hospital, Teaneck, New Jersey, to Charles Harry Beck (1910–1990) and Dorothy Jane Beck (1911–1992). Lives at 6 Hunting Drive, Dumont, New Jersey. He has two older siblings, Ken and Carol.

1963

Moves with family to Chalfont, in Bucks County, Pennsylvania.

1968

Graduates from Central Bucks High School. After graduation starts work at Paramount Packaging Corporation in Chalfont (the first of several packaging companies at which he would work over the next twenty years) as a gofer in the art department, then moves up to the positions of mechanical artist, package designer, and art director.

1985

Moves to Bristol, Pennsylvania, where he will live for the next ten years.

1988

Marries Elaine Ferry, a nurse with three teenage children from a previous marriage. Bristol Riverside Theatre in Bucks County presents an exhibition of Beck's portraits, including one of his father.

1990

Leaves the corporate packaging position to pursue a career as an artist. Starts attending the Pennsylvania Academy of the Fine Arts part-time. Has a portrait exhibition at Designer's Corner Gallery in the Philadelphia neighborhood of Manayunk. Presents the *Mostly Local* exhibition at the Bristol Riverside Theatre.

1992

Wins the Pennsylvania Academy's Frances D. Bergman Memorial Prize (an award of $150 to a student for the best representational painting) for a nude self-portrait. Ends his studies at the academy. Work is selected for the first Bucks Biennial at the James A. Michener Art Museum in Doylestown, Pennsylvania.

1993

First work accepted for Phillips' Mill Annual Art Exhibition.

1994

Elected president of Artsbridge in Lambertville, New Jersey, and serves through 1996.

Beck and his brother, Ken, c. 1957

Self Portrait as a Hockey Player. Acrylic on canvas, 24 x 20 in., 1978. Private Collection

Business card, c. 1988

Eight Self Portraits. Oil on canvas, 22 x 20, 1992. Collection of the artist.

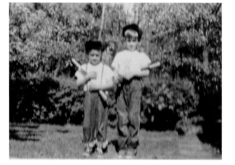

A Thousand Words column, January 2014

Beck hosting *The River,* WDVR-FM, Sergeantsville, NJ, c. 2009

The Wall. Oil on panel, 10 x 16 in., 2008. Private Collection

Christian Street, Philadelphia. Oil on panel, 8 x 8 in., 2011. Private Collection

2005

Begins writing a monthly column, "A Thousand Words," for *Primetime* magazine. In 2008 the magazine's title is changed to ICON. Included in special invitational exhibition and the book *Celebrating 75 Years of Art,* marking the Phillips' Mill Community Association's seventy-fifth anniversary.

2006

Is included in American Artists exhibition at London's Stephen Friedman Gallery. Paints England's Silverstone GP2 racing series. Begins biweekly visits to Matheny Medical and Educational Center, Peapack, New Jersey, to create a painting series for an Arts Access fund-raiser.

2007

Opens *Robert Beck: Through the Windows* at Robert Schonhorn Arts Center at Matheny. *Robert Beck Retrospective 1997–2007* opens at the Trenton City Museum at Ellarslie. Self-publishes *Office Report,* a collection of his essays.

2008

Is included in the *New Hope Art and the River* exhibition at the James A. Michener Art Museum. Moves into new gallery space at 204 North Union Street, Lambertville, where he presents eight solo and group exhibitions over the next ten years. Begins to design and build a house in Solebury, Bucks County.

2009

Moves into the house he designed with architect Michael Raphael. Wins Bucks County AIA Honor Award–Residential Award. Hosts *The River,* a radio interview program on WDVR-FM. Robert Beck *On Hand* exhibition held at Pennswood Art Gallery, Newtown, Pennsylvania.

2010

Paints his Senegal series in Africa.

2011

Opens solo exhibition *Philadelphia Heartbeat* at Rosenfeld Gallery, Philadelphia.

1995

Separates from Elaine Ferry. They divorce in 1996. Moves to the Bucks County village of Lumberville and rents rooms above a barn, christened the "Treehouse" by the artist. Wins Best in Show for *The Reading* at the Bianco Gallery Annual Juried Exhibition. Wins the McClintock Award at the Phillips' Mill Annual Exhibition, the first of nine awards Beck will receive through 2018. Starts teaching at the Art Room in Oldwick, New Jersey.

1996

Has a solo exhibition at Riverside Studios, Pottersville, New Jersey. Begins teaching at Flemington Art School, where he will continue to teach for the next four years. Paints first live-event fund-raiser for FACT Bucks County.

1997

Is included in the Pennsylvania Academy's Fellowship Centennial, *The Unbroken Line.* Teaches at Artworks Trenton through 2000. Wins the Edith Emerson Prize at Woodmere Art Museum.

1998

Organizes solo *Lambertville Portfolio* exhibition at Rago Arts and Auction Center. Exhibits *Second Crossing* at Washington Crossing Historic Park Visitor's Center.

1999

Organizes solo exhibition *Things That Happen at Night* at Rago Arts and Auction Center. Is included in a four-person show at the Michener Art Museum. Makes a month-long painting trip to the West. Opens the Gallery of Robert Beck on the second floor of 21 Bridge Street, Lambertville. Begins teaching there and will continue to teach through 2014. Wins Michener Museum Purchase Prize at the fifth annual Artsbridge Prallsville Mills Exhibition.

2000

Organizes solo *Faces & Figure* exhibition at Rago Arts and Auction Center. Selected as a finalist for a Pew Fellowship in the Arts.

2001

Organizes the exhibition titled *Simple Pleasures* at the Gallery of Robert Beck, the first of ten solo exhibitions he will present there.

2002

Spends a week on a Mississippi towboat for a series of paintings. Featured in the book *Artists of the River Towns: Their Works and Their Stories,* vol. 1, by Doris Brandes.

2004

Begins personal relationship with Doreen Wright, a corporate executive, which leads to domestic partnership in 2007 and marriage in 2012.

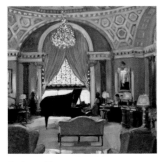

Lambertville Portfolio

50 Small Paintings by
Robert Beck

All in or of Lambertville
All under $500.00

April 19-25, 1998
Monday – Saturday, Noon-5

ARTIST'S RECEPTION
SUNDAY APRIL 19, 2-7 PM

David Rago Auction Center
333 N. Main Street • Lambertville, NJ
609/397-9374

Lambertville Portfolio invitation, 1998

Beck painting on the Mississippi River, 2002

The Gallery of Robert Beck, Bridge Street Studio, 2003, *American Farm* exhibition

Doreen Wright and Robert Beck, 2014

Steinway Showroom
Oil on panel
16 x 16 in., 2011
Collection of Betsy Hirsch

Donna Marie
Oil on panel
12 x 16 in., 2012
Collection of Rosemary Tottoroto
and Raymond Mathis

Elizabeth Osborne, Beck, and Mo Brooker for the Philadelphia Sketch Club Medal, 2014

Over East catalogue, 2016

2012

Visits Jonesport, Maine, for the first time. The National Arts Club presents the solo exhibition *Robert Beck: Iconic Manhattan.* Marries Doreen Wright.

2013

Makes the first of what will be annual trips to Jonesport. Most of his Bucks County Playhouse series is included in *Local Mill Makes Good: Celebrating 75 Years of American Theater at the Bucks County Playhouse,* an exhibition at the James A. Michener Art Museum.

2014

Awarded Philadelphia Sketch Club Medal for Excellence and Contribution to the Arts.

2016

Maine Maritime Museum solo exhibition *Robert Beck / Over East* opens in Bath, Maine.

2018

Closes his Lambertville gallery. Opens *Archetype* exhibition as New Hope Arts Legacy Artist. Wins Wingert Award at Phillips' Mill.

2020

Elected Signature Member of the American Society of Marine Artists.

2021

James A. Michener Art Museum solo exhibition *It's Personal: The Art of Robert Beck*

One of Us
The Unique and Universal World
of Robert Beck

Most people want community, whether it be their
neighborhood, school, place of worship, or sports teams.
People of all backgrounds want to find friendship, support,
and validation in the group they become a part of. An in-
dividual who finds community discovers a world to be part
of, one where they can both be themselves and be part of
something larger, and often more meaningful, than anything
they could have done themselves. Artists are typically seen
as lone wolves who work independently in their studios, but
their need for community is as strong as anyone's, perhaps
because their work is so solitary. "Schools" of artists are
really no different from other type of communities, except
for the fact that artists organize over a style or an approach to
their art.

There are many reasons why there has been an art
colony in Pennsylvania's New Hope area for more than a
century. The beautiful bucolic landscape with rolling vistas
punctuated by the Delaware River and streams throughout;
proximity to the important art and commercial centers of
New York City and Philadelphia; historic old homes with
outbuildings to accommodate studios and workshops; light
that artist Fern Coppedge compared to that of Italy: all
were enticements for painters. But truth be told, there are
many areas in the state, and in the country, that could fit
the bill. What made the New Hope area unique is its sense
of community.

In 1899 a forty-year-old artist named William Lathrop
and his family settled at Phillips' Mill in New Hope, and
their Sunday-afternoon teas for their friends, students, and
neighbors made the location even more charming. "Both
Lathrop and his wife possessed a natural generosity of
spirit that, along with his reputation and the beauty of the
Bucks County landscape, soon began to attract other artists
to the area," wrote curator Brian Peterson in his landmark
exhibition catalogue on the artist. "Within a few years, the

Lathrop home became the hub of a growing art colony along
the Delaware, centered in New Hope."[1]

The community they created on those Sunday afternoons
would be institutionalized in the Phillips' Mill Community
Association in 1929, when a group led by Lathrop bought
the mill across the road as a combined community center
and art gallery and held the first of what would be annual ex-
hibitions there. Many of these artists would later be referred
to as Pennsylvania Impressionists.

At nearly the same time that Lathrop arrived in Bucks
County, Pennsylvania, an informal group of Realist artists
in Philadelphia set themselves apart from and challenged
American Impressionists and academics. Led by Robert
Henri and inspired by Thomas Eakins, the group followed
Henri's credo—"art for life's sake," rather than "art for art's
sake." First in Philadelphia but most famously in New York,
they captured the vitality of those cities and their people in
broad, calligraphic forms, which they rendered from life "on
the run" or from memory, using skills that most of them had
cultivated as newspaper illustrators.

Because these artists often focused on the less fortu-
nate, the group was called the Ashcan school, although
their paintings generally offered positive depictions of their
times. The Philadelphia group added new members when it
arrived in New York, and they formed their own community
of like-minded artists and their friends and families, often
socializing together and providing support and entertain-
ment for one another.

These two communities of artists, the Impressionists
and the Urban Realists, would define the American art
world in the first quarter of the twentieth century, and their
approaches would become intertwined, creating the DNA
helix for generations of artists who would follow. Ashcan
artist George Bellows would go on to paint bucolic land-
scapes that would not look out of place at a Phillips' Mill
exhibition, while Pennsylvania Impressionists such as
Robert Spencer, and later Charles Ward, would be just as
interested in the working man and his world as in a beautiful
fall or winter landscape.

The New Hope art colony and the Ashcan school were

just two communities that coalesced around art. There was no formal membership or initiation rite. As the novelist Ken Kesey memorably wrote of the anarchic group, the Merry Pranksters, that formed around him as they prepared to travel across the country together, "You're either on the bus or off the bus." In late-twentieth-century America, especially before the rise of the internet, there was no hub of information that directed artists to communities of like-minded individuals. The artists had to discover or create them for themselves. Yet somehow they did.

One artist went looking for such a community in which to pursue his dreams. He found one whose history stretched back a century and was being remade on a daily basis. That artist was Robert Beck, and the community he found helped him become a painter, designer, writer, gallery owner, teacher, organizer, philanthropist, home builder, and radio host.

For more than thirty years, Beck has been an integral part of the Bucks County art community, particularly in New Hope and Lambertville, New Jersey, as both a leader and an iconoclast. His documentary-style painting from life, which draws on both the Impressionists and the Realists, sets him apart from many of his contemporaries yet has earned him awards, critical recognition, and a healthy market for his work. He has written extensively for publication about art, particularly his art and how it came to be and what it reflects of the artist. As a great raconteur, both on paper and in person, he may be the most articulate voice the Bucks County's visual art community has ever produced. His journey from solitary artist to community leader is both unique and emblematic of the path an artist can follow in contemporary American culture.

"I grew up in a learning environment," recalled Beck, who was born in 1950 as the youngest of three children. The family lived in Dumont, a small community in northeastern New Jersey. "My father was right out of *Popular Science* magazine. He flew planes, built interesting things, and he was an electronic wizard. He was organized in mind and habits and explained things very well."[2] Beck has called him a scientist but most accurately a "marveller," and that

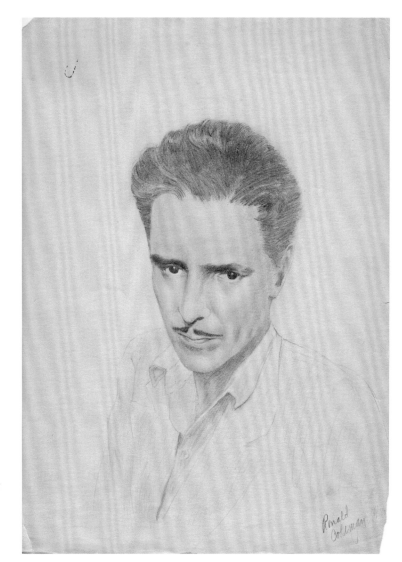

Ronald Colman
Charles Beck (1910–1990)
Pencil on paper
8½ x 11 in., c. 1945
Collection of the artist

wonder led him to become a self-taught savant.

Charles Beck expected his children to experiment as he did, and to follow their own passions (as long as they did not interfere with his). Beck remembers a Sunday night when he was quite young and sitting in front of the television drawing cartoons when his father showed him how to shade a cylinder. "Until then the pencil and paper were instruments for battles between ships and airplanes," remembered Beck. "Shading a cylinder opened a new world, starting with trains. I drew steam locomotives with round boilers and round smokestacks, attacked by planes at first, then standing on their own, and then in the company of other shaded forms—houses and the like."[3]

The father would later show his son drawings of actors that he had copied from the entertainment sections of newspapers when he was young man and later in the US Navy.

"My father did beautiful pencil drawings from photos of famous people, many on Navy stationery while on a Pacific island in World War II," his son recalled. "Those were a huge influence on me as a child. I recognized early that visual imagery was a powerful language, and it became a tool I used, much like those in my father's shop."[4]

These works, a selection of which still hang in Beck's home, "raised the ante," as he put it, for the budding artist.[5] Beck's sister, Carol, who is nine years older, was an art student, and by copying work that she or their father did, Beck enjoyed a small taste of celebrity at school for his drawings.

In 1963, when Beck was thirteen, his family moved to Chalfont, in Bucks County, settling in one of the area's first residential developments. "We were surrounded by farmland," he recalled. "There was a grange, there was a country store. I used to be able to walk to the end of one of the roads I lived on where there was a farm, and I would fish in the pond. I used to climb a tree and wait for the cows to come back to the barn, and I would drop out of the tree onto their backs. They would go nuts. Their only defense was to try to rub you up against the tree. I'm surprised I still have legs."[6]

Beck is a true product of postwar America and has in many ways lived a series of iconic childhood experiences: sledding in winter, biking to the circus, fishing in local streams and ponds, working at an old gas station, and having a distinct memory of the Woodstock era, even though he discovered years later that the memory was not accurate.[7] He would later draw on these experiences for both his paintings and the short essays that he published as a monthly column in *ICON* magazine. In high school, as an "art kid" with a clear talent for drawing, he wangled an opportunity to paint three murals at the WMCA, located in the old high school at Broad and Court Streets in Doylestown, a project he now claims was simply a way to get out of class. But in fact he put a lot of effort into the details of the decorative murals, which showed a tug-of-war between good and evil as well as race cars based on images he had seen in magazines.[8]

After graduating from high school, and unsure of what to do next in his life, Beck went to work in a local factory, Paramount Packaging in Chalfont. He had hoped to get a

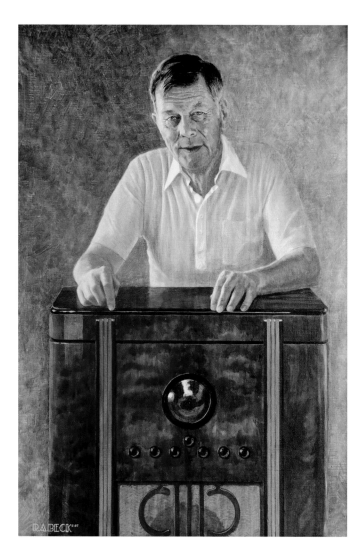

Charles Beck
Acrylic on canvas
36 x 24 in., 1988
Collection of the artist

job as a forklift operator like one of his friends, but when his new employers learned that he had an art background, he was hired as a gofer in the company's art department. When a job at a drawing table opened up, Beck was hired to do mechanical commercial art such as graphics on bags for bread and potato chips. Back then, this was no simple task. In the age before computers, it required considerable manual skill to reproduce logos and integrate the designs onto an actual package.

Beck also learned the mechanical process by which items were manufactured and printed and as a result became known as a problem solver, so much so that when there was a problem in the art department or the press room, Beck would often be included to find a solution. In this regard, his years of seeing his father experiment stood him in good stead. "When they decided to wipe out the entire art

department, get rid of all the artists, get rid of the staff and everybody, they kept me," Beck remembered.[9] In what was now a managerial position, he reorganized how that part of the company worked, but he felt stuck. Despite his knowledge of both art and the mechanics of printing, without a college degree he was unable to go anywhere else...until the Chicago Tylenol murders in 1982.[10]

"The Tylenol thing happens, and there's a company that made shrink bands, which nobody really needed, and then suddenly everybody needed it," Beck recalled. "I knew the graphics and the printing of that kind of specialty rotogravure."[11] This knowledge of the bands that are used to prevent tampering allowed him to escape his job at Paramount and move to a larger packaging firm in Bensalem, Pennsylvania. In his spare time, he played goalie on a local hockey team and played guitar, but he always had a drawing board in the back room where he did what he described as "very graphic stuff, and poster-y kind of things"[12] for specific purposes. He even entertained the idea of becoming a cartoonist because he felt that he had mastered the four-panel comic strip.

"Once I moved to Bristol [in lower Bucks County], I became a little bit more of the artist,"[13] he explained, and he began to paint in acrylic. "I'd see something, and I'd wonder if I could paint it, a subdivision of how I do it now. Something would catch my eye, and I'd like to try to paint that."[14] Eventually he began to see portraits as what he described as the "epitome" of art and started to concentrate on those when he painted, even if he was painting only on the weekends.[15] While he continued to find success in the corporate world, he became increasingly dissatisfied and uncomfortable with the emptiness of the work.

In 1988, after marrying Elaine Ferry, a nurse with three teenage children from her first marriage, and living in Bristol, Pennsylvania, where a room in his house was set aside for a studio, Beck left the corporate world. With Elaine's encouragement, he decided to see if he could make it as a portrait painter.[16] He was thirty-eight.

Beck had initial success in the Bristol area painting restaurant owners and funeral home operators.[17] He even received a commission from the Grundy Foundation to paint the portraits of Senator Josephy Grundy and his sister Margaret, whose home became a museum for the Bristol area.

"I love painting people," Beck said in a 1988 interview when his paintings were exhibited at the Bristol Riverside Theatre. "I think there is as much of my personality in the portraits as the sitter, which creates a personal view as opposed to a generic portrayal." And, he added, "I am a romanticist, and if anything, I tend to flatter. I am not interested in brooding statements. I want people to enjoy looking at my paintings."[18] One reviewer described Beck as a "very competent portrait painter," adding, "He takes a different approach, placing people in their natural surroundings, not posed or stiff, but comfortable."[19]

Beck's portraiture relied on photographs, and his workmanlike approach was not unlike his corporate graphic work. "I would trace photos and draw contour lines at the borders between values," he explained. "I used them as a guide for the painting. At first, I separated light and dark using high-contrast graphic photo papers, and later learned to divide the photo into multiple values as it was projected on the canvas."[20]

Despite his ability to secure commissions, Beck realized that he needed more education in art and technique, and for him that meant only one place: the fabled Pennsylvania Academy of the Fine Arts in Philadelphia, the nation's oldest art museum and school. "I knew that if I was going to paint for a living, I had to learn from good people," he explained, adding drily, "You can teach yourself. It only takes 150 years."[21] He was pleasantly surprised to be accepted as a student despite his age and lack of formal education.

At the time he enrolled in 1990, the academy maintained a fairly classical approach to teaching art, having students draw sculpture casts and work from a live model. Beck attended part-time for two years, soaking in as much instruction as he could. He spent a considerable amount of time in the school's library studying techniques and learning about other artists. Like his father, Beck is more or less a self-taught artist. Other than high school classes, his two part-time years at the academy represented his only formal

training. As a forty-year-old student at the academy, he understood the discipline that was required to succeed, yet his age did not stop him from being open to new ideas and fresh approaches. He stopped working in acrylic and has worked ever since almost exclusively in oils.

"I was in love with the whole thing," Beck said of his time at the Pennsylvania Academy. "If I had a problem, I could turn around to somebody and say what do I do about this? And it was interesting to know that half of them had no idea."[22] In the process, he discovered that one could learn as much from a failure as from success. That discovery was liberating.

An instructor named Al Gury, now chair of the museum's painting department, recommended a landscape painting class. "He told me I would find things I need to know about color by painting plein air," Beck wrote more than a decade later. "I was more interested in figurative work until I took an Academy class held at the Horticultural Society Gardens in Philadelphia, which opened my eyes to the power and challenge of painting the landscape."[23]

The class was taught by painter Louis Sloan,[24] and in exchange for tuition Beck was responsible for setting up everything in Fairmount Park and busing the students between the park and the school. One day's assignment was to paint the Shofuso Japanese House and Garden, but Beck was more interested in painting the park's bus "graveyard,"

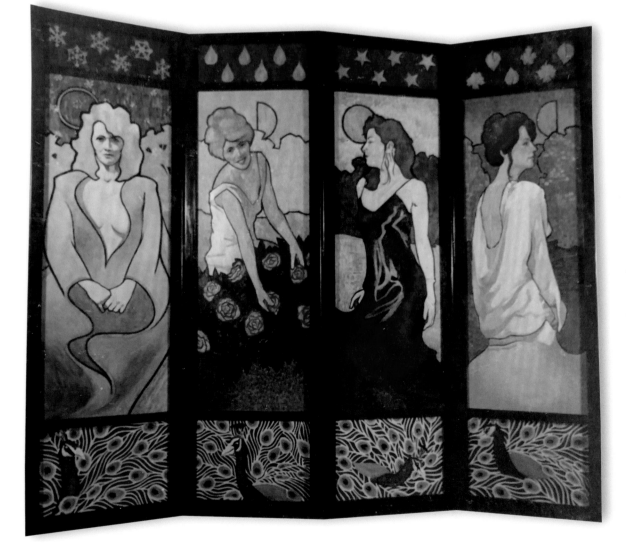

Four Seasons Folding Screen
Oil on canvas mounted to MDF, wood, metal hinges. 60 x 72 in., 1991
Private Collection

Beck painted this Alphonse Mucha–inspired folding screen as part of his end-of-year presentation at the Pennsylvania Academy of the Fine Arts. Artist and academy teacher Peter Paone described it as "one of a kind."

PAFA
Oil on panel
16 x 20 in., 2011
Collection of
Doreen Wright

a scraggly lot where old and broken buses were kept. The change in subject proved a seminal moment in his career.

"One day a guy on a lawn mower comes by and says, 'Hey, how much you want for that?' And I said seventy bucks. He says sold. I was painting on canvas taped to a panel. I could just pull them off and throw them away or whatever. We taped it to the hood of his lawn mower. He gave me $70 out of his pocket, and he went away."[25] The decision to paint what interested him, and the reaction of someone who was clearly not looking to buy a painting but responded to what he saw, was not lost on the artist.

Beck's time at the academy proved to be transformational. It not only introduced him to new approaches in painting, particularly plein air painting, it also gave him the confidence to continue his life as an artist. "What I needed was a boost," he remarked three decades later. "I needed a launch."[26] The experience proved to be a springboard to a new career, a new place to live, and a new life farther up the river.

A New World

At the Pennsylvania Academy, Robert Beck continued to learn, and even won an award, the Frances D. Bergman Memorial Prize, for his work, but he decided to leave in 1992 after two years of part-time study. "I want to take what I have now and go forward," he explained to himself, "rather than do this academic churn. You can do that forever."[27] His marriage had begun to deteriorate, and he was eager to move on to the next phase of his life and career. As painting took primacy in his life, he gravitated more to New Hope, the artists' colony along the Delaware River.

Established in the late nineteenth century, the "colony" was still active nearly a century later, but it was more diffuse, with artists and galleries scattered up and down the river. The focal point remained New Hope and Lambertville, New Jersey, a community just across the river that was reached by a small bridge, but the vibrant arts culture that defined the area in the mid-twentieth century had frayed as the century came to a close. The Bucks County Playhouse, whose often star-studded, Broadway-quality performances had brought hundreds of people to New Hope each night, became a nonunion house in the mid-1980s, presenting what were essentially community theater productions that played to smaller crowds. The shift meant fewer visitors to the area's galleries. Yet a handful of exhibition spaces persevered, and new ones continued to open to showcase the works of the region's artists.

Beck was hired in 1992 to make frames in Grace Croteau's Riverrun Gallery, a SoHo-type gallery in Lambertville that gave nontraditional artists a place to exhibit their work. Croteau, Beck remembered, "was one of those people that connected people to other people."[28] Croteau was also a cofounder of Artsbridge, a nonprofit organization designed to nurture local arts and artists and create opportunities to display their work. New Hope has had artist community organizations for almost as long as artists have lived in the area, from the Phillips' Mill Community Association in the 1920s to the Independents in the 1930s to the New Hope Art Associates in the 1940s and '50s, and so on. Artsbridge continued and expanded on that tradition, providing a network and community for local artists. Beck soon got involved.

He had found the job through a printmaker named Susan Roseman, another community-minded artist. "She was involved in everything,"[29] Beck explained. Roseman had her own gallery in Stockton, New Jersey; Beck had made the rounds of the area galleries with his portrait-heavy portfolio; and the two, along with Roseman's husband, the painter James Feehan, became friends. Beck began to exhibit portraits and watercolor landscapes at her gallery in monthly themed shows of works by local artists. His role in the arts community expanded as he developed a reputation as someone who could and would help other artists, and in the evenings he was frequently asked to assist with the hanging of exhibitions. He embraced the artist's life as he painted during the day and framed artwork and hung shows at night.

Beck continued to commute from Bristol, but he knew that if he wanted to immerse himself in the art world, he needed to move to the New Hope area. While attending a sketching class at the Lambertville studio of the painter Bernard Ungerleider, a fellow artist told him of a space on a farm outside of Carversville, Pennsylvania, that was for rent.[30] There he met Jeff Baumann, a woodworker, photographer, and "this great philosopher type,"[31] as Beck put it, who was married to Marilyn Moody, the head of the Bucks County Free Library. Although the rent was more than he could afford, Beck offered to help Baumann out on the farm when needed, and in December 1995 Beck moved into rooms above the barn, a space that was christened the "Treehouse," with a mailing address in nearby Lumberville. He would live there for the next twelve years.

Baumann was an important presence in Beck's life during this period. "Jeff and I had this very interesting relationship," Beck said. "We were really good friends, but we had our own lives. We had this tremendous respect for each other, and we helped each other."[32] They would often spend part of the morning chatting before Baumann would

**Winter Moon
(Jeff's House)**
Oil on panel
16 x 20 in., 2001
Collection of
David R. Gross

begin to critique Beck's most recent paintings. "He would walk over to what I was working on and say, 'What are you doing here?' And it would be that thing that I thought I could get away with. There's always that thing you think you don't have to deal with. And he forced me to look at things. He forced me to realize that you can't ignore your way to getting better."[33]

Beck considers his time on the farm "my birthing spot," adding, "I got a chance to go back to ground zero."[34] In his mind he shed his past there. His life in the corporate world was over, his marriage was done, his time at art school finished, and his social time with friends playing hockey or guitar was behind him. "I think being out of the view of people who know you is a great benefit when you reinvent yourself," he said.[35] He saw Baumann and Moody as "the right people, because they encouraged me to be a new thing. And they weren't judging me by the limitations they knew I've had for the last ten years. They didn't know who I was.

That's a key ingredient to my being able to move forward."[36] It was in his earliest years at the Treehouse that he was first able to focus almost exclusively on his art.

Although Beck felt that he was making big strides in his art, the judges of juried shows, for the most part, did not share his opinion. The James A. Michener Art Museum in Doylestown, Pennsylvania, had selected a Beck oil for its Bucks Biennial in 1992, making him one of forty-eight artists chosen for the exhibition, but many of his submissions were rejected by local juries. Then in the spring of 1995, the Bianco Gallery, then the area's premier gallery and the one that helped revitalize the interest in and market for the area's historic painters, announced a submission deadline for its second annual juried exhibition.

Beck wanted to submit a work but balked at the $20 registration fee. The sum represented a good bit of food for the struggling artist, and he was reluctant to throw it

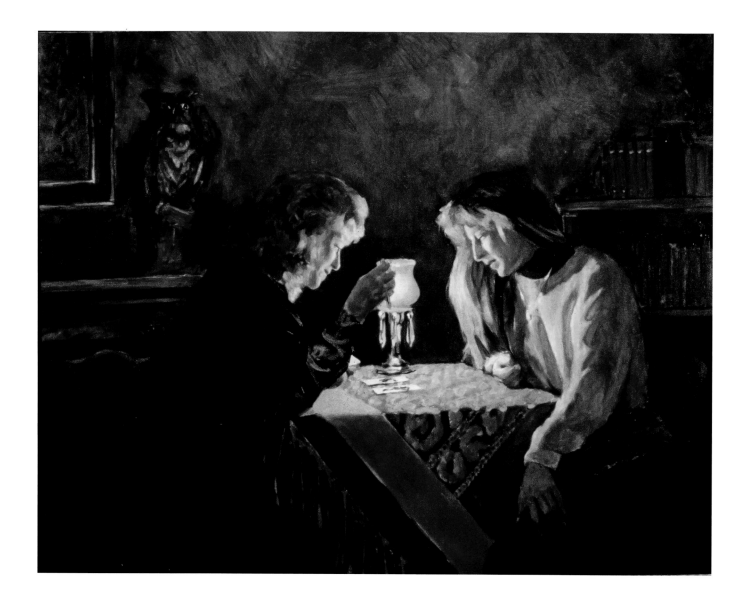

The Reading
Oil on panel
26 x 33 in., 1995
Private Collection

away on possible rejection. But Susan Roseman encouraged him. "She shamed me, she said, 'I'll pay for it,'" he said. "She had less money than I did. So I said okay, I'll put it in."[37] He submitted a recent work, an intimate interior titled *The Reading* that depicted two women, illuminated by a small lamp, hunched over a table for a tarot card reading. The painting was closer to the work Beck had created before moving to New Hope in that it was figurative, academic in technique, and firmly rooted in Realism. But his handling of the light, the mystery of the reading, and the intimacy of the women, who were his wife and her daughter-in-law, was compelling.

In fact, the work proved so captivating that it was not only accepted for the exhibition but also chosen as Best in Show by the three judges, a group that included John Ravenal,[38] then associate curator of twentieth-century art at the

Philadelphia Museum of Art. A photograph of the painting appeared in the *New York Times*, and the work was reproduced on the poster for the gallery's 1996 exhibition. The recognition, which included both a $1,000 prize and a studio visit by gallery owner Frank Bianco, validated Beck's life choices and proved a catalyst in his career as a painter.

"I felt singularly honored my painting was selected," Beck said at the time. "Frankly, I didn't expect to be included because a lot of the good shows in the area prefer watercolor milk cans." Of the painting's chiaroscuro lighting, he said, "I like the dramatic light. I think everything I do has a basis in light, the effects of light. I do a lot of landscapes, and you become well versed at light. You spend the better part of your day chasing it around."[39]

The work sold on opening night, and at the conclusion of the exhibition's run, Beck returned, as he put it, to "say goodbye to the painting that had broken the ice."[40] The

Kimono
Oil on panel
36 x 48 in., 1994
Private Collection

"Up to that point, I was doing a lot of paintings that were accepted subjects, things that people thought were paintings," he said. "And I too followed that. Square-rigged ships and barns and charming images." But, he added, "I wasn't really satisfied with that. I was ready to move forward and burst out of that." Then he had something of an epiphany. "It was one particular night that I was looking through slides and putting together a sheet for something," he said. "I looked at the progress, I looked at what I had there. And I realized that I was looking at, sort of like my footprints through the snow behind me, coming up to me. I saw them as a direction.

"I said, Okay, I'm heading this way. I don't know what this way is, but I could see this trail coming up behind me. I'm doing the right thing. I have to have faith in the fact that if I keep pushing, opportunities will open up, I will learn new things, and I will find this new stuff I should be doing. What it did was it gave me a little bit more confidence to not hold back, not be afraid of trying something new."[43]

Grace Croteau of Riverrun Gallery, recognizing Beck's artistic ability along with his leadership qualities, invited him to become the president of Artsbridge in 1994. For Beck the position opened doors to a wider community as the group's four hundred members included both older artists who had been working since the mid-twentieth century and were generally well known or well respected along with contemporary artists who were just making a name for themselves. The position introduced him to people in and outside of the arts community and solidified his place in the local firmament. He found himself talking to members of other organizations, and he was soon a regular presence in the local media, a feat he has maintained for nearly thirty years.

Beck believed that the organization could be more than a "kaffeeklatsch" and could actually make art a force for good in the community. In 1996, as president of Artsbridge, he proposed an artist-in-residence program for schools in Hunterdon County, New Jersey. Working with the United Way, the group raised $10,000, including $1,250 from Artsbridge members, to bring artists into schools to work with high school students.

next time he would see the work would be four years later when it was hung on the wall of the Michener Art Museum for a four-person invitational exhibition. Despite the fact that his work was accepted for two other important exhibitions that year and despite winning another prize, when Beck submitted a painting to the Bianco juried show the following year, he was rejected.[41] The irony was not lost on him.

Beck was moving away from portraiture, but the surrounding landscape gave him ample subject matter; as he put it, "There are paintings at every window and bend in the road."[42] At this point he was working exclusively in oils. Although he admired how the well-known Bucks County Impressionist Edward Redfield painted—plein air—capturing the scene in one go while in the field, Beck knew that he did not want to re-create either those paintings or paintings done by so many other historic artists of the area.

"It's a great opportunity to showcase local artists and to give students a chance to understand what the lives of artists are really like," Beck said of the undertaking. Art, he added, was "a balancing element, necessary to ministering to the mind and the soul as much as making a living satisfies physical needs." The program, which continued for years after Beck's presidency ended in 1996, was another way that he contributed to the artistic life of the area he was now calling home.

The community that Beck discovered in New Hope changed his life, literally. "This is an extraordinary period for me being surrounded by artists," he said in May 1996. "Over the years I've had many good, capable friends—and I still do—but now my friends are mostly artists. This is something which has helped me focus on this aspect of my life. I live art. Everything I do, which is not laundry, is art."[44] He had come to the area purposely to find such a community. He had recognized not only the talent in New Hope but also the safety net that a community of artists could provide, as well as a market for his work.

It was in this milieu that Beck interacted with established artists like Mira Nakashima, Tom Galbraith, Pat Martin, and Paul Matthews, each with their own distinct style, medium, and process. He also benefited from the vitality and imagination of a younger generation of artists. It was a place where Beck thrived. He was prolific, painting nearly every day, and often producing five or more paintings a week.

Beck was essentially living off the sales of his paintings. While he exhibited his work at several galleries, he was always looking for new showcases. In 1996 a relatively new local restaurant called Church Street Bistro approached Beck about finding artists who wanted to display their work on the restaurant's walls.

"I take a dim view of that because sometimes it's just a business looking for free decoration," Beck said of the request. "I wanted to make sure it benefited the artists as well, so I suggested a project where an artist does a work based on the chef's food, and the chef creates a dinner based

Pat Martin
Oil on panel
10 x 8 in., 1999
Private Collection

on the artist's work. I called it 'Art & Cuisine.'" Beck identified six artists who were invited to a group dinner where the chef presented a creative, "artistic" meal. The goal was that each artist would create a work inspired by either the chef's food or the evening itself. Beck then encouraged the chef to become familiar with each artist's work and design a menu around it.

The project was classic Beck. "Everybody would win," he explained. "The 'Art & Cuisine' evening, along with information about the concept and the guest artist, would be well promoted. It gave the Bistro something to publicize that local papers would think was artsy and interesting, and it positioned them as creative. The event would draw new people to the restaurant who were familiar with the artist, generally liked the arts, or just saw it in the paper and thought it was different. The artists got two great meals for free (actually four—they got to bring a guest to their dinner as well as the group dinner), a bunch of exposure from releases and ads, all of the proceeds if their work sold,

Art and Cuisine
Oil on panel
12 x 16 in., 1997
Private Collection

and if not, they got to take it home once the next series of dinners started."[45]

Beck's roster of artists for the project included the photographer Jack Rosen,[46] the painters Mavis Smith,[47] Paul Matthews,[48] James Feehan,[49] and Pat Martin,[50] and the printmaker Susan Roseman.[51] When Beck chose himself as the guinea pig for the first set of dinners and the evening was a bust, he simply redoubled his efforts. The project became a palpable success, with the dinners selling out, and ran for two cycles, promoting a total of twelve artists.

It was Grace Croteau who suggested a new approach to Beck that would alter the course of his career. In June 1997, after seeing a small Beck painting of a scene along the Delaware with Lambertville in the background, she suggested doing a whole show on the same theme. Beck saw the possibilities of doing a show of Lambertville scenes but decided that rather than try to pitch the idea to a gallery, he would present his own exhibition. He thought of approaching the Kalmia Club, one of New Jersey's

oldest continuously operating women's club, which had a "clubhouse" on York Street in Lambertville that had once been a Quaker meetinghouse.

Out for dinner one night with Croteau, the two ran into David Rago and Suzanne Perrault, the owners of a well-established and internationally known auction house in Lambertville called the Rago Arts and Auction Center. Rago had only recently started appearing on public television's *Antiques Roadshow* as an expert in the field of American ceramics and art pottery, and business at the auction house was brisk. Croteau introduced Beck to the couple and told them that he was going to be presenting a show of his own. In spite of having just met Beck, they offered their space for a week and offered to send invitations to their client list.

Amazed and inspired by their generosity, and realizing the opportunity had just grown, Beck painted another twenty pieces before he opened in April 1998 an exhibition called *Lambertville Portfolio*, a series of fifty small paintings, some or all of which had been painted in Lambertville. This represented the first time he had painted a sustained series of

works on a single subject; along with a handful of landscape scenes, there were paintings of Archie's hot dog truck, the interior of Sneddon's Luncheonette, the Acme food store, and the LTC coffee shop. The paintings captured multiple aspects of Lambertville, both big and small, historic and contemporary. Painting a series gave the exhibition not only a unifying theme but also an opportunity for the artist to see his subject in many different lights.

"I am not a landscape painter, a Bucks County painter, or the next whoever," Beck said in describing his work. "I paint the things life parades in front of me: nudes, biplanes, moonlight on the river, and a Volkswagen bug. It shows how much I enjoy a parade."[52]

The exhibition gave him an excuse to be everywhere in town, to paint the life around him much the way members of the Ashcan school had painted but in Bucks County. For those artists, the city was their muse. Beck found his in Lambertville. He was painting Bucks County the way many of his well-known predecessors had, but he was doing so on his own terms, capturing the area as it was during his time. He was extending the tradition rather than simply imitating it.

The *Lambertville Portfolio* exhibition was both a culmination of what Beck had been working on for ten years and the beginning of a new chapter in his life. With its success, he was no longer the struggling artist finding his way, unsure of what to paint. He was now a recognized member of the community who projected a distinct voice in his paintings and had both a clearer idea of what he wanted to do and the resources to go forward.

Lambertville Portfolio

" *It's a good thing Bob Beck is such a pleasant guy—because it is hard to avoid the Lumberville, Pennsylvania, artist across the river in Lambertville these days. One day he is sighted at Riverrun Gallery. Then a Beck landscape appears at the Coryell Gallery, and postcard reproductions of his work are on sale at the Sojourner. Next you spot his picture in the Rivergate Books' newsletter, or he turns up for a meal at the Church Street Bistro. And one evening a week or so, he can be found painting from life at the Boat House bar in the Porkyard.*[53]

—PAT SUMMERS, *U.S. 1*

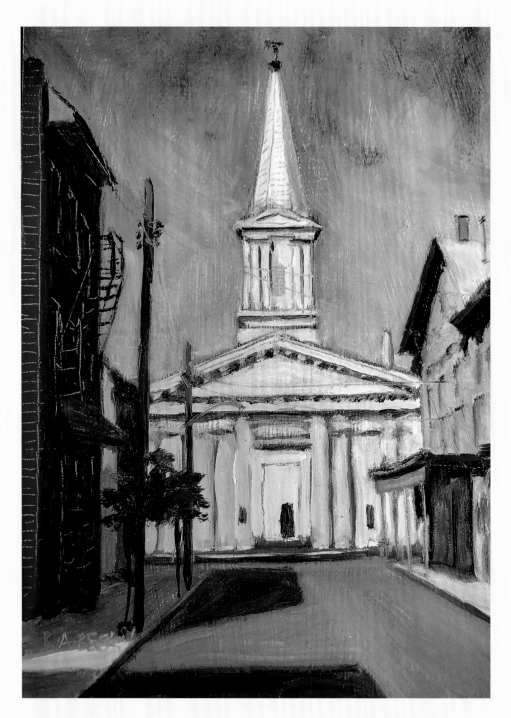

Grace Croteau's suggestion to paint Lambertville, and David Rago and Suzanne Perrault's offer of the Rago Arts and Auction space, led Robert Beck to discover a new approach to painting as well as a fresh way to present it. Creating a suite of small oils on panels on a single subject represented a further stage in Beck's evolution as an artist, one that allowed him to fully explore his reaction to his subject and the nuances that made that subject so compelling. In the case of his current subject matter, Lambertville, the choice was also very personal.

"I paint things that are part of my life," he said at the time of this first self-produced, one-man exhibition, which ran for six days at the Rago Arts and Auction Center. "Lambertville provides such support and encouragement for the many artists that live and work in the area." And he added: "This exhibition for me is a personal recollection of the time I have spent here. It reflects what I consider to be the basic elements of what one defines as home."[54]

Beck did not consider this series a portrait of the town but referred to the small works as "letters from home." Although he had been living in the area for only three years, he had been visiting regularly for nearly a decade, and with this project he fully immersed himself in the Lambertville community. He explored every corner, shop, and meeting place to find the most telling aspects and the most artistically rewarding scenes to paint. This series freed him from working alone in his studio. Equipped with a portable French easel, he worked plein air, on-site, whether the location was a laundromat, a pizza parlor, a five-and-dime, or a yard with clothes hanging on the line. He even started an unofficial residency at the Boat House bar, where he spent most Tuesday nights painting in a corner of the room, often to the delight of customers.

"I paint from life because that's how you can tell what something looks like," Beck explained to one interviewer on the eve of the exhibition opening. "If you paint from a photograph, the best you can hope for is something that looks like the photo. There's an astonishing amount of information essential for what I do, and you'll find most people who paint this way will agree, there's a lot more visual information about form if you're on site. You know, you're working with three dimensions to begin with. You can move a little bit and see how far back something is. You can't do that with a photograph."[55]

For Beck, the challenge of painting in real time with an audience occasionally watching added excitement to the work. With the real threat of failure hanging over him, the pressure trained him to learn his strengths and weaknesses and to add those to his calculations as he painted. He taught himself to anticipate what would change in the scene as he worked so that he could capture that essential information while it was still available.

"In situations that might change," he wrote of his approach in an essay in 2007, "I also try to develop the whole painting as quickly as possible, leading each advance of the total image by addressing the elements that threaten to disappear. When they go, I bring what remains in view up to that level of

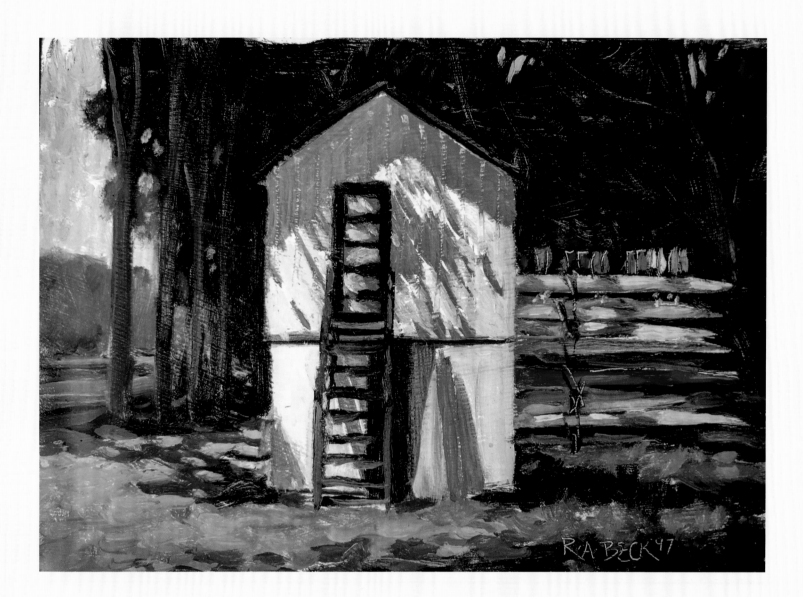

above
Fishing Shack
Oil on panel
5 x 7 in., 1997
Collection of George and
Janet Holbrook

opposite
Church Street
Oil on panel
7 x 5 in., 1997
Collection of Liz Holbrook
Woyczynski

completion, and the painting is done at that state. Or should be. Sometimes things happen by surprise, and I'm screwed. It's a gamble."[56]

Lambertville Portfolio was a gamble all across the board. He'd never painted so many works on one theme, and he barely knew the people at Rago. In addition to creating the paintings in the exhibition, Beck framed all the works, designed the invitation, wrote the press release, and installed the show. But the gamble paid off, and the exhibition was a rousing success. He asked two friends to staff the show with him, and when he arrived an hour before the opening, it was clear that he was going to need help: there was a line out the door. He sold two-thirds of the works in the first three hours of the show.

The event solidified Beck's place in the community, a place where he saw people who were "making films, writing books, doing paintings here."[57] It seemed a long way in both time and space from a moment a few years earlier when he was painting on the side of the road near Bristol, where he lived at the time, and a driver passing by yelled at him, "Get a job!"

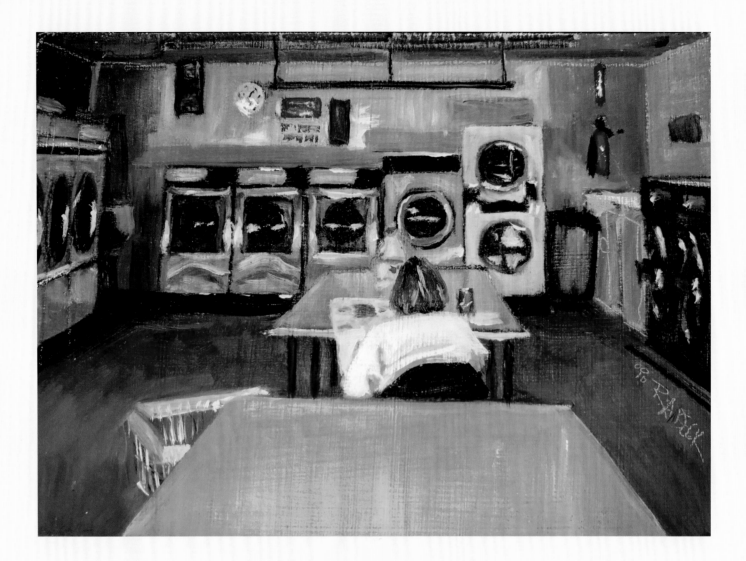

Laundromat
Oil on panel
5 x 7 in., 1997
Private Collection

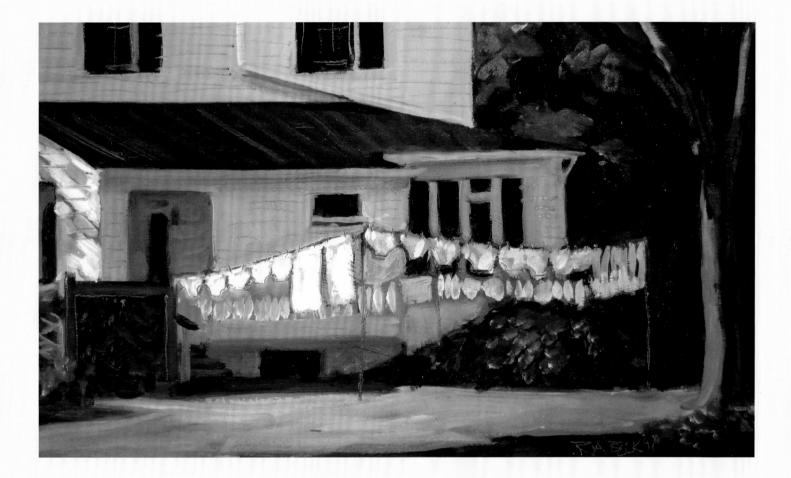

Jockey Club
Oil on panel
5 x 9 in., 1997
Private Collection

East End
Oil on panel
5 x 7 in., 1997
Collection of George
and Janet Holbrook

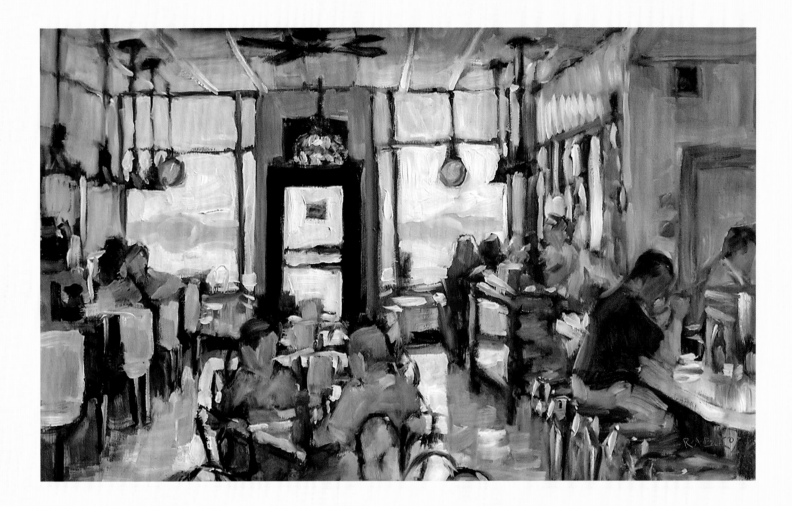

Sneddon's Luncheonette is a fixture in Lambertville, and Beck has been a regular since he arrived in town. When the health department ordered the diner to replace its bathroom, which required patrons to walk through the kitchen to get to it, Beck painted the restroom to preserve this vanishing part of Lambertville history. Here he shows an typical breakfast at Sneddon's.

Breakfast at Sneddon's
Oil on panel
5 x 7 in., 1998
Private Collection

Second Crossing and a New Beginning

There are many iconic paintings of Bucks County. The list includes a winter landscape by Edward Redfield, a pastoral view along the Delaware by Daniel Garber, and an autumn painting by Fern Coppedge, to name a few. Familiarity with those paintings diminishes with each mile traveled from New Hope, as is the case with much of America's regional art. There is, however, one painting of a Bucks County scene that is known throughout the country, if not the world. The work wasn't painted by a Bucks County artist, and the scene is just off the shore of Bucks in the Delaware River. But the image is so famous that a town is named for the event it depicts.

Washington Crossing the Delaware, painted in 1851 by the German American artist Emanuel Leutze, commemorates George Washington's crossing of the Delaware River with the Continental Army on the nights of December 25 and 26, 1776. That surprise attack is often regarded as a significant turning point in the Revolutionary War. Yet despite other paintings of this heroic scene and its own historical inaccuracies, it is Leutze's mammoth oil, approximately twelve by twenty-one feet, that has been reproduced countless times in books and magazines and on classroom walls. The image is even on the back of the official New Jersey state quarter.

Robert Beck decided that he would take a stab at this legendary scene. As he would write later, "Of course, there is always the question of why bother. But 'why' is a question for scientists. Artists go directly to 'why not.' That is their value."[58]

The project began with a conversation in the fall of 1998 with a park educator at the Washington Crossing Historic Park while Beck was working on his next one-man exhibition, a collection of nighttime paintings titled *Things That Happen at Night*. The two men discussed how inaccurate Leutze's painting was, although they understood that the painter was creating not a historic document of the event but a piece of propaganda.[59]

For starters, Leutze's Washington was too old and would never have been standing at the front of the boat due to both the Hessians and the inclement weather. Leutze had set the scene in daytime, with sunlight breaking through the clouds, despite the fact that the actual event took place at about two o'clock on a cold, dark night when snow was falling. In addition, the Betsy Ross flag is probably wrong because the flag was not adopted by the Continental Congress until six months later. "The Leutze painting is very impressive," Beck concluded. "It's a patriotic period piece. But I refocused my brain and wondered, 'What does this thing really look like?'"[60]

Beck became preoccupied by how the scene must have actually appeared, explaining, "I painted this scene many times in my head before I painted on the panel."[61] He considered the combined lighting effects of an overcast sky, the river's surface clogged with ice, and the veil of sleet "playing its own reflective tricks."[62] He also did his research. He stood on the New Jersey shore at night during a snow squall. He went to the annual Christmas Day reenactment of Washington's crossing, and he would eventually return to the park to sit in a Durham boat, similar to the one that Washington is said to have used on that occasion. "It is not my intention to challenge a national icon," Beck was quoted as saying at the time. "My view is merely different."[63]

Already thinking of painting in a nocturnal setting, Beck composed a scene that is much more brooding than the original, one that looks at the boats head-on from the Jersey shore. The night is dark, painted in cool blues and grays, with specks of snow and sleet throughout. The only lights are the fires the American soldiers would have left burning on the shore and the reflections on the ice choking the river that night. The men in the boat are huddled together, drawing on the historical supposition that Washington would have been hunkered down between men on this rough journey. A flag is suggested but never defined.

"You don't have to add symbolism or make anything up," Beck wrote of the work. "The facts are more than enough... The symbolism is all there in the event. Re-crossing the river, awful weather conditions, navigating the floes. Those

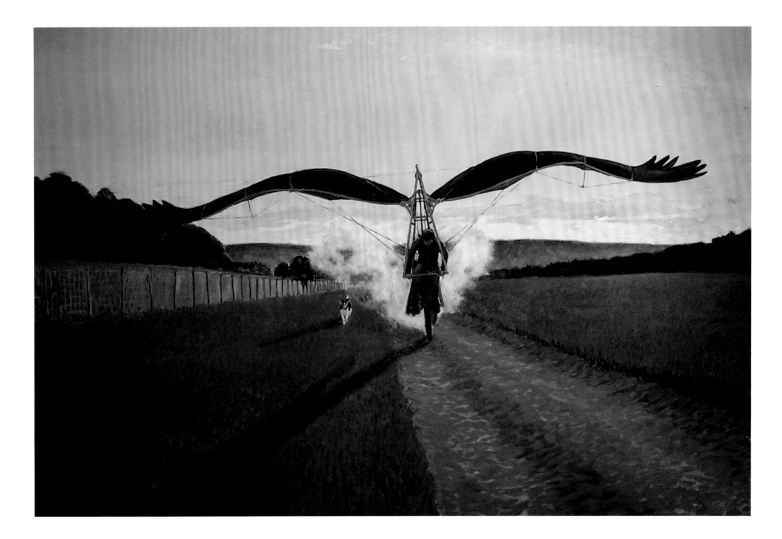

Faith
Oil on panel
33 x 48 in., 1997
Collection of Karen Hertzog

men did not know they were at a pivotal point in history. This painting is about their spirit. This painting is about courage."[64]

Inspired by Leutze's original, Beck had painted his own massive work, a panel nearly three feet by five-and-half feet that he titled *Second Crossing*.[65] The title is a double entendre, referring to Washington's crossing of the Delaware and a tip of the hat to the more famous painting that inspired him.

"I have a great reverence for what was going on that night," Beck wrote, "but I didn't concern myself with the buttons and the bullets. I just wanted to show this thing coming at you from out of the dark. If you were there, you wouldn't have seen a whole lot."[66] It was a bold move by an artist who had only ten years of experience under his belt, but one that ultimately proved worthwhile. The work was unveiled at the Washington Crossing Historic Park on Thanksgiving Day, 1998, and remained on view there through the end of the year, a period during which

thousands of people visited the park for both the holiday re-enactment and the "rehearsal" for the public that takes place several weeks earlier.

By this point Beck was becoming a force to be reckoned within the regional art scene. After winning a number of high-profile awards and having exhibited at the Michener Art Museum's second biennial, he was invited to be part of a four-person show of contemporary artists at the museum, an exhibition titled *Bucks County Invitational III: Contemporary Painters*. Alongside works by the abstract artists Alan Goldstein and Pat Martin and another representational painter, Eric Sparre, Beck showed thirty-seven of his works, including *The Reading* and *Second Crossing*, along with twenty-seven small paintings that he rounded up from collectors who had purchased works from his *Lambertville Portfolio* show and other exhibitions.

Despite showing an unusual work titled *Faith*, which depicts a man on a bike with large wings mounted in the rear barreling down a country lane with a dog running at the rider's side, the critic from the *Philadelphia Inquirer*

concluded that the abstraction in the show was superior to the realist works on view and that those paintings "could benefit from work with more edge than Beck's straight-from-the-textbook conventional realism." Nevertheless, the critic admitted, "Beck may be an actual Academy realist, but in terms of subject matter he's also an omnivore."[67]

This backhanded compliment amused Beck, and he would later write in an essay, "The permission to paint whatever subject appeals to me is found in my *Artistic License* under the section titled, *Privileges*. However, the document makes no mention of there being a right to afford food, clothes, and rent, which is a real concern for any artist."[68]

At this stage of his career, Beck seemed to be having no problem with the need to support himself. *Second Crossing* was bought by a collector who had stopped by the Treehouse to pick up a painting he had recently purchased at another show. When the collector saw the large panel still unfinished on Beck's easel, he put a quarter on the table, said, "First dibs," and soon added the work to his collection.

Beck's second self-produced one-man show at Rago Arts, *Things That Happen at Night*, a suite of forty small paintings[69] all done at night, was a reaction to the positive response to the nocturnal scenes in his first show. The response indicated to him that there was an audience for this style of work, and he was right. "Here in the land of famous dead Pennsylvania Impressionists, night scenes (or nocturnes, to fancy it up a bit) are highly received," he wrote later. "The ones seen in museums and galleries usually include a Pennsylvania stone farmhouse and/or a barn, most often nestled into a snow-carpeted winter setting that glows in generous amounts of moonlight. There will be a lit window with a warm light that reflects on the surface of the snow to draw the attention, provide a compositional anchor, and establish an opposing reference for the dark values and cool illumination that make up the rest of the image. That's what they painted a hundred-plus years ago because that was their world."[70]

Beck's night life reflected his world, and he painted outdoor scenes such as a firemen's carnival, a moonlit field

leading to a horse farm, and various indoor activity, including a New Hope high school basketball game, the kitchen in Lambertville's Bell's Tavern, and action at a local fencing academy. Although painting at night did address the issue of the changing light that affected the painting of a daytime work, it presented unique challenges in that Beck was not always able to see his panel or his palette, which occasionally resulted in surprises. Nonetheless, he didn't regard his nocturnal images as much different from his other works.

"The process of painting at night is different only in the way still lifes, landscapes, interiors, and figures are different from one another," he explained. "The subject has its own identity, but the artist is still describing the effects of light on form. During the day there is one source of light. At night there are often multiple sources of light with assorted colors and intensities, giving unique character to the surfaces they illuminate. But the way light decays over distance and across forms is consistent, and that consistency helps us understand the physical world around us. The artist doesn't have to know the physics, just observe the effects and avoid misstatement."[71]

Most of the work in the exhibition was painted in or around Lambertville, which caused one writer to conclude, "Like American novelist Sherwood Anderson, Lambertville has become Mr. Beck's *Winesburg, Ohio*."[72, 73] Beck was in town so frequently, in fact, he was practically a local landmark. "I have been painting in working environments across this and other countries for a long time, but there is a difference painting in Lambertville," Beck wrote to a local reporter. "People are more familiar in general with working artists around here, and most of the locals aren't surprised to see me painting just about anywhere.

"A number of people came into Fiddleheads," a local florist, "while I was set up on top of the walk-in refrigerator where they keep the flowers," he added. "They just glanced up and said, 'Hi, Bob.' Some asked when my next show was or how my summer was going, as if we met in the supermarket. When I painted DeAnna's Restaurant, customers waved as they sat down and left. A few came to say hello and see how I was doing, but nobody was surprised. People in

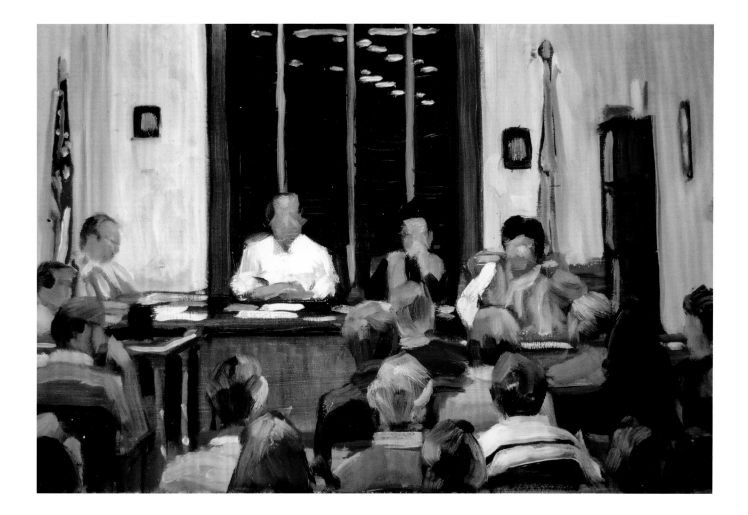

Council Meeting
Oil on panel
12 x 16 in., 1998
Private Collection

Lambertville expect me to be painting."[74]

Beck's paintings were successful because they captured his enthusiasm for what he was doing. He chose subjects that were interesting to him, and his mission was to capture not only what they looked like but also what they felt like. On the occasion of his second show at Rago's, a critic wrote that Beck's work was "at once charming and well-focused and interesting in its lack of precision and seeming casualness. I can imagine that chef in a busy kitchen with Beck painting away right under his nose...and that's just it. I can imagine it as if I had been there."[75]

That was exactly what Beck was striving for; he wanted to tap viewers' memories and sensations. "The majority of my paintings are done directly from the subject in one sitting," he once explained. "They depict where I am, what catches my interest, and what it feels like to be there. That last bit—the feel part—is tricky. It's an element that emerged in my art after years of working from life as I began

to recognize, mostly by paying attention to my mistakes, that doing things in different ways changed the impression one got from the image. Color, value and contrast relationships could be manipulated to alter mood. Brush calligraphy could invoke weight, energy or motion. I began to arrange things in accordance with my experience. The reason why I was drawn to a subject became part of the image. It got very personal."[76]

There is a through line that extends from Edward Redfield capturing a landscape on-site in one day and Beck's similar approach to other aspects of the Bucks County landscape. Yet Beck didn't find the term "plein air" an apt description of what he was doing.

"There are plenty of people for whom painting an interior doesn't qualify as plein air because the term means 'outdoors' in French (give or take)," he wrote in an essay. "But those of us who think saying, 'Painting the actual thing while you are standing there' is cumbersome, know that addressing any subject outside the studio using a portable painting kit is all the same anyway, and we tend to bandy the term about

roughshod. I'll admit, it's not true plein air. Sue me."[77] He began to use the phrase "documentary painting," which seemed to satisfy critics and viewers who could be stymied when describing his work.

Despite the use of the word "documentary," Beck was not interested in recording every aspect of the scene before him. "By presenting *only* the information that the viewer would have observed, I create the best chance for that viewer to arrive at the same interpretation," he explained. "I don't believe that adding details creates a sense of reality. Creating a realistic discovery process is what gives life-sense to a painting."[78] In other words, he was not trying to re-create reality but to evoke, as he put it, the "cocktail of emotions that emerged from the encounter, what Picasso called the thing behind the thing."[79]

Beck discovered that painting unusual subjects went beyond connecting to the viewer of the work. He got to meet people and learn about what they did in the worlds in which they were most comfortable. "I rarely find resistance to my request to paint," he wrote to a reporter who asked about his style of painting. "Curiosity wins out. Having an artist work on site is a nice change of pace, and the employees enjoy seeing it come together. From my end, it's a ticket into places I wouldn't otherwise get to experience, and some of my hosts have been very hospitable. In fact, in going out of their way to accommodate me they become collaborators."[80]

Beck found that he could get comfortable even in the most chaotic situations, and he had trained himself to focus on the subject at hand. "I'm a background guy," he explained. "I'll stand in the corner and just watch and blend into the wallpaper. I can sort of feel myself doing that. I'm so good at just focusing...and it's not everything else disappears; it's just I don't care about everything else. I care about this, and I can zero in on it, then I'll go out there and I'll paint. I did that early on; I'd go out and I'd paint, and people would see me, they'd come over and talk to me, I'll talk to them. It's been part of the development."[81]

He also realized that painting in public could be a double-edged sword. He had to make the best painting

Beck painting the Delaware River flooding, 2004

he could because whether or not he eventually sold the work meant little to the audience who saw the painting created right in front of their eyes. He also had to be patient, sensitive to those around him, and willing to deal with the questions of anyone passing. "If you are going to put yourself out there in front of somebody, you have to deliver, 'cause if you're there and you're a jerk, that's what they'll remember," he explained. "You're advertising the wrong thing; you might as well stay home."[82]

Fortunately he enjoyed working under the difficult and distracting circumstances that come with painting from life. "Painting is in one regard an act of intimacy," he said. "When something attracts me, I take it as an opportunity, not to paint a pretty picture, but to function at a near

Masonic Lodge
Oil on panel
12 x 16 in., 2020
Private Collection

euphoric level for a while. The finished work is a record of that experience."[83]

Now that he was a part of the town, he knew that he needed a local place to show his work, as the Treehouse was definitely just a place where he lived. "Customers came and were looking at some paintings that were on my couch, and I thought, this is not the way I'm going to make it into a bigger time than this. I was represented by the Ruth Morpeth Gallery in Pennington for the past two years but I wanted a studio where people could visit."[84]

A local electrician told Beck of a second-story space in the Masonic Lodge at 21 Bridge Street in Lambertville. Thus in 1999 this space became his workplace, a showplace, and a gathering place for local artists. Bernard Ungerleider had a studio on the same floor, so in effect Beck had completed another circle, as it was in Ungerleider's studio four years earlier that he had learned of the Treehouse. The older artist still hosted a Thursday-night class and a Tuesday-afternoon class, and when he died, Beck brought the classes over to his studio.

"You might have Pat Martin show up, or Paul Matthews show up, and people that would surprise you, because you would think that they're beyond that," he recalled. "And they'd be right next to people who, it's their first year trying to figure out which end of the pencil to use." He added: "It such a beautiful community. You can invite the ghosts, invite the opportunities and make things happen. That's what I was doing."[85]

Just before he opened his own space in Lambertville, he would do one more show at Rago Arts and one at Morpeth.[86] In this Rago exhibition, called *Faces and Figures*, he presented small portraits of many of the artists and visionaries of the area such as Jack Rosen, Jim Hamilton,[87] John Larsen,[88] Dee and Robert Rosenwald,[89] and Mira Nakashima.[90] Beck used the project as an opportunity to meet many of his subjects, almost all of whom were longtime members of his community, or to get to know them better. The show drew on Beck's past as a portrait painter and on his documentary style in that all the images were the result of one sitting. The series of small paintings stand as a fascinating record of a storied arts colony on the eve of the twenty-first century.

In his own space, Beck went on to present two exhibitions annually. Painting every day, he frequently produced 150 paintings a year. His paintings from life were done in a matter of hours, which gave him the luxury of spending more time on his studio paintings or business. He organized a spring show for small paintings from five by seven inches to eight by twelve inches, typically documentary paintings of the world around him, whether it be a person, place, or thing. A second show at the end of the year was reserved for larger pieces, studio works that were drawn from on-site paintings and images from his own mind, such as *Second Crossing*.

At this point Beck decided to challenge himself in a way he never had before. A natural homebody, he describes himself as a "stay-put person." As he would later write, "Part

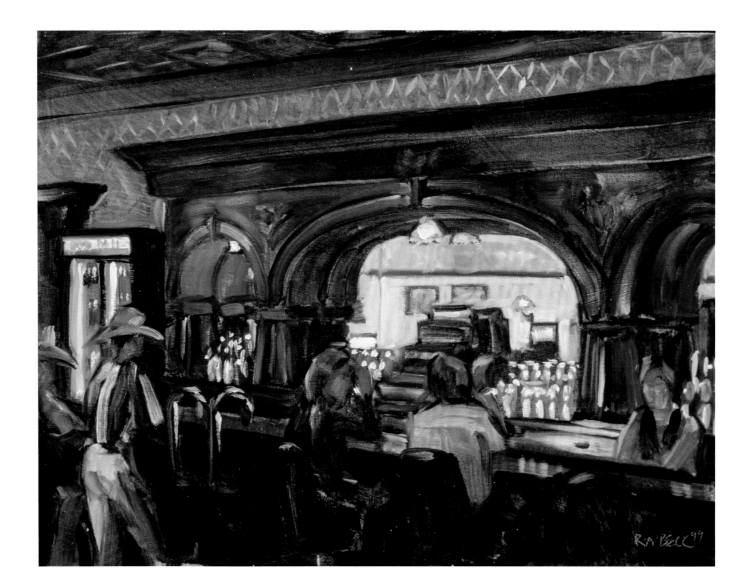

The Montana Bar
Oil on panel
12 x 16 in, 1999
Private Collection

of that has to do with being self-entertaining. Give me a paintbrush, a pen, or a book, and let me know when dinner is ready. I rarely look outside of myself for fulfillment. If I need a different world, I make one. My work has evolved into an examination of who we are as people, and 'we' are pretty easy to find, so I don't wander too far afield. I'm also not comfortable in an unfamiliar place or one in which I don't know anybody. That might be a security issue, but I think of it more as needing an anchor. When I do go away, painting is my safe spot to hole up."[91]

He nevertheless wanted to do his own version of the classic European grand tour. He wasn't comfortable traveling to Europe, but he had been out West, visiting Colorado, Wyoming, and Montana, and he was attracted by the landscapes and the great distances. "I was asked why I chose to go to Wyoming and Montana and paint," he once mused,

"and I joked that I wanted to go to a foreign country where they speak English."[92]

The solo trip, which ended up being a monthlong sojourn, was all about painting. His goal was to paint two documentary paintings a day and return home to present an exhibition of the work. The show was mounted in the fall of 1999 at Ruth Morpeth's gallery in Hopewell, New Jersey, and for the first time Beck included text panels on the walls with stories and quotes. He was discovering that sometimes he had more to say about a subject even after he had finished painting it. The self-imposed challenge of the trip out West had resulted in a fresh outlook and even new approaches to his work as he entered the twenty-first century.

In just over a decade Beck had almost totally reinvented himself. In the next decade that reinvention would take new shapes, offering him new ways to explore more aspects of his art and experiment with new mediums of expression.

American West

" *29 days, 3,600 miles, 6 states, 44 paintings. Towns with no buildings, bars with bullet holes in the wall, places sacred and defiled. I painted a rodeo clown, a saddle maker, a 70-year-old lady that has cooked buffalo burgers in Gardner Wyoming for 40 years, and the morning man at KPRK in Livingston Montana, at work. The Devils Tower at dawn, the railyard at Laramie, crop dusters outside of Billings, and a horse sale on the Colorado prairie. I stretched out on the ground and watched a meteor shower at one a.m. in the Bighorn Mountains after splashing up the Shell River on a blue roan. I spent the 4th of July with Native Americans. I touched noses with a moose.*[93]*

—ROBERT BECK

his is how Robert Beck summarized his pilgrimage to the West in the summer of 1999. Somewhat familiar with the area from two previous trips, including his 1988 honeymoon, he decided to return to that part of the country both to test himself and to make the journey all about painting. Before departing, he sent out his painting supplies, including a portable easel, and six specially made cases to hold up to five fresh wet paintings in individual slots, "like ammo boxes." He also took sheets of eight-by-twelve-inch canvas to tape to the back of his smaller panels and glue on new panels when he returned home.

He had a simple if ambitious plan: "The basic principle was, paint something in the morning and when the sun gets high, ten, eleven o'clock, do your traveling. Go someplace, find out what's there, and then, in the afternoon paint it, or during the night, paint it. So, go for two a day."

In the era before widely available GPS and the internet, his only guide was a map and a Mobil Travel Guide. Beck described the trip as a "grand tour." But unlike the nineteenth-century travelers who made their way around Greece and Italy to savor the art, the culture, and the roots of Western civilization, Beck was going to create art about the culture and beauty he found in the "civilization" of the West. He painted saloons, the "You-R-Next Barber Shop and Guns" shop, and a rodeo. In Miles City, Montana, he painted inside "a large saloon with high tin ceilings, marble floors, and a century-old back-bar. Ringing the top of the room were

opposite
Horse Sale
Oil on panel
12 x 16 in., 1999
Private Collection

below
Wyoming Herd
Oil on panel
12 x 16 in., 1999
Private Collection

shoulder-mounts of the lead steer from every cattle drive to thunder its way up through Oklahoma and Wyoming since the Territory days."

When cowboys started to filter into the bar after five, it got noisy, and Beck feared that someone would trip on his easel "and turn my face into ground chuck." As the image started to appear on his panel, "some of the cowboys moseyed over to check it out. From then on, the most crowded spot at the bar was the one in front of my easel. Hats were waved and drinks were bought, which is one of the reasons I like painting in bars."[94]

Locals were a great source for suggestions of places and things to paint. But when they couldn't direct him to anything interesting and he didn't see anything on his own while traveling, he went down to the local

chamber of commerce office to see what upcoming events they had posted. Often he found towns and places that were almost western versions of Lambertville with their unique characters, scenic views, and long histories of doing things their own way.

Eventually, the stress of travel, the search for new subjects, the weather (Beck encountered both torrential rain and a tornado), and simply being away from home took a toll on the forty-nine-year-old artist. After breaking down in tears after seeing a traveling version of the Vietnam Veterans Memorial twenty-eight days into the trip, he knew it was time to return to Bucks County. He had achieved his goal and had done so on his own terms. He emerged from the monthlong solo experience with a better understanding of who he was both as an individual and as

an artist, as well as how far he could push himself. He had never been away from Bucks County for so long since he had moved to the area at the age of thirteen and has never been away for that long since.

Looking back on the journey twenty years later, he came to an important conclusion: "I think that helped me a great deal," he said, "to the point where everything became a possibility."[95] The adventure gave him the confidence to pursue his form of documentary painting outside of Bucks County, eventually leading to his painting series on a weeklong trip on a Mississippi barge, in Philadelphia, New York, England, and Africa, and his most in-depth series, works painted over many years in a small fishing communities in Maine.

Silver Dollar Bar
Oil on panel
8 x 12 in., 1999
Private Collection

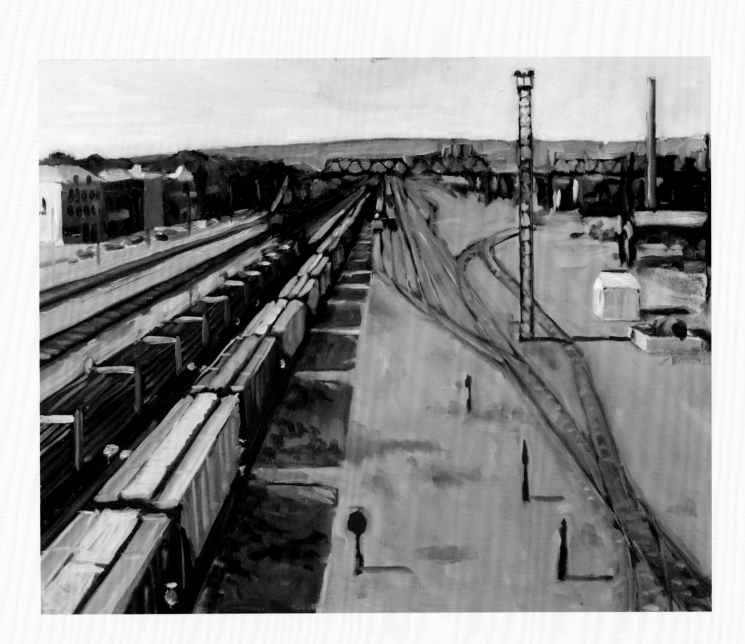

Laramie Yard
Oil on panel
16 x 20 in., 1999
Private Collection

Post Office, Alladin, WY
Oil on panel
12 x 16 in., 1999
Collection of Suzanne
Perrault and David Rago

U-R-Next Barbershop & Guns
Oil on panel
12 x 16 in., 1999
Private Collection

Reaping What You Sow

In the early summer of 1999, Lambertville was poised to celebrate the sesquicentennial anniversary of its founding. Inspired by a 1993 photograph of a street in the Italian city of Siena filled with long tables set for a feast preceding the celebrated annual horse race, the Palio di Siena, local residents decided to hold a similar celebration. They closed Union Street and lined it with long tables with space for a thousand people for Lambertville's Great Spaghetti Dinner. Prizes were awarded for everything from best costume to best table setting.

The event, a true community effort, was organized by Jim Hamilton, a set designer and restaurant owner who supervised the food while town council members led setup and cleanup crews and other volunteers had kitchen duty. Artists of all stripes made gigantic street puppets and performed music to accompany the spaghetti and meatballs, which led some in the crowd to join in for a rousing rendition of such memorable lines as "When the moon hits your eye like a big pizza pie, that's amore."

Yet one artist stood above the rest. In fact, he literally stood above all 1,100 people who attended because he was stationed on the roof of the People's Store, an antiques and art gallery on Union Street. Robert Beck chose that spot to document this remarkable event in oil paint for posterity. "It was one of those moments when life imitates art," wrote one reporter. "A Norman Rockwell painting of small-town America, no, make that a Bob Beck painting of small-town America."[96] For many

in Lambertville, it wouldn't be a community event if Beck had not painted it.

"If you're going to do what I do, you have to really immerse yourself in the community," the artist said some months after the event. "You can't paint in a closet and expect to survive. You have to contribute."[97] His documentary paintings, like this one, served many purposes. They allowed him to record the world around him, to raise his profile in the community, and to have fun.

By this point Beck had established himself in the community and was earning his living by doing what he loved. But he also understood his responsibility as a community member. Even at the earliest stages of his painting career he had decided, "If I had the opportunity to use my art to help other people, why not?" And he knew that this involved "going out and being with other people, helping other people, teaching other people, and relying on that kind of MO, that process, that formula."[98]

One way Beck discovered that he could help others through his work was to offer to paint a fund-raiser while it took place, and at the event the painting would be auctioned for the cause. Such an undertaking played to his strengths, as he could produce a fine work in three hours and could do so despite all the distractions a public event would offer.

Among the first fund-raiser painting he did was for FACT Bucks County, an organization that provides information and financial assistance to people with HIV. Beck had lost friends to AIDS, and in the mid-1990s, when he began this work, the disease was perhaps the most critical issue in the gay community. Both the event and the painting were a success, with Beck's small oil-on-panel image of the events of the night raising a substantial amount. He returned to do the same thing at a number of FACT Bucks County events, but that first evening would provide a model for Beck's altruistic efforts for the next twenty years.

Another beneficiary of his efforts was Lambertville's annual Shad Fest, and

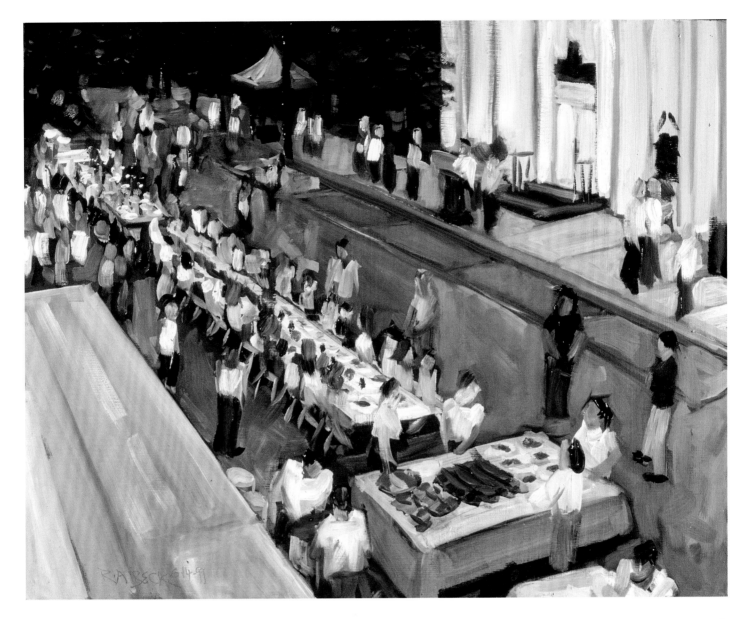

Spaghetti Dinner
Oil on panel
16 x 20 in., 1999
Collection of Rick and
Kathy Buscavage

through it, art students. Started in 1981 by local artists as an art show to commemorate the annual return of the fish to the Delaware River, Shad Fest blossomed into a communitywide celebration of shad and the arts.

On the last weekend in April, Lambertville's streets are filled with entertainment by local bands and dance companies. Artists and craftsmen line the thoroughfares while visitors and residents stroll through town enjoying the creations of their friends and neighbors. Shad Fest poster blanks are available in the weeks before the show, and artists are encouraged to create an image to be auctioned off during the event to raise funds for the Jim Hamilton Shad Festival Scholarship, which goes to local students who intend to study art in college. Over more than thirty years, the auction

Robert Beck painting the Great Spaghetti Supper, Lambertville, NJ, 1999.
Photograph by Jack Rosen

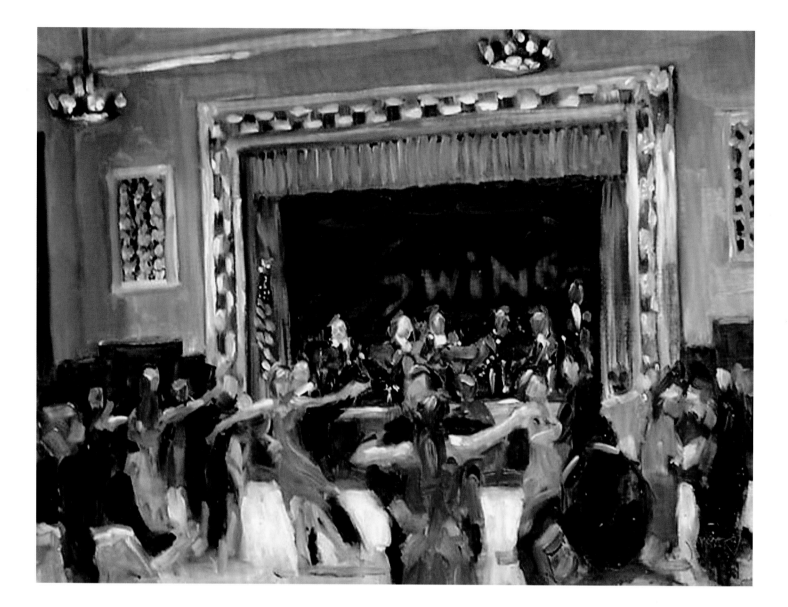

Swing Benefit
Oil on panel
12 x 16 in., 2007
Private Collection

has raised close to a half-million dollars to help young artists.

For more than twenty-five years, Beck has produced poster paintings for the auction, with images ranging from scenes associated with shad fishing to images of Lambertville itself. It was not unusual for his poster paintings to do very well in the auction. In 1997 he painted the empty shell of the local Acme supermarket, which had recently closed, and sale of the poster painting raised the most amount of money that year. The following year he painted the same scene, but this time "its porcelain panels stripped off exposing the support structure of the once iconic neon lit tower," one observer wrote. "We might all have forgotten if Bob hadn't captured it in linseed and pigment."[99]

Beck made and donated paintings for many organizations. For the Riverside Symphonia he contributed a series

of paintings, created while set up in the orchestra when members were rehearsing and performing, that were sold for the benefit of the ensemble. A local choreographer who was working with residents at the Matheny Medical and Educational Center through their Arts Access program inspired Beck to visit the facility, which served people with profound physical disabilities like cerebral palsy and spina bifida, and he immediately knew he wanted to do something to help.

"My first visit brought me to tears more than once, and I'm only incrementally getting better at control each time I go back,"[100] Beck wrote in 2006 when he was making biweekly visits over the course of a year to paint a series of landscapes from the center's windows, which overlooked Peapack, New Jersey. He believed that a series of beautiful vistas would raise more money for the Arts Access program than institutional interiors, and he committed a year to the project because, as he put it, he saw his paintings as a

way "to help out in instances where I couldn't do it any other way."[101] Beck also painted "live event paintings" to help raise money for a number of organizations, including the Michener Art Museum and the American Cancer Society.

In 2009 Beck learned of a local family whose members had lost their home and their jobs and were living in their car; the news came from the director of a local charity called Fisherman's Mark, an organization dedicated to helping people in need in the Lambertville area. "That's something that has always scared me," Beck wrote. "Once you slide past a tipping point it can take all you have just to stay alive. How hard is it to claw back when you don't have an address or a phone? Or when your clothes wear out and no one wants to look at you? How about when you have a bad tooth and no money? Then it was mentioned that the homeless couple have three girls. A bleak scenario took on a sharper and darker dimension. I couldn't imagine how difficult it had to be to hold a family together, living in a car. I had to name it—create an image that expressed my understanding—in order to move forward."

Like the Ashcan artists he admired, Beck wanted to convey the family's dignity "without surrendering my image to cliché." This was a painting done not for fund-raising purposes but a work he did for himself. He did research, he wrote, to learn how "homeless people network to subsist safely out of view. And how relief organizations struggle to provide essential services to those who suddenly find themselves on the short side of the American bell curve, pushed to the edge because somebody has to suffer when our economy contracts."[102]

Then he painted the family at night in a parking lot in the back of what could be a convenience store: five figures

2016 Shadfest Poster
Oil on heavy paper
11 x 17 in., 2016
Private Collection

amassed around a station wagon, living their lives as if it were somewhat normal to be there. The dark tones convey the cold and the desperation of the scene. Yet it is not hopeless. A child sitting on the hood of the car reads a book, and another appears to be preparing or eating food around what could be a stove. These people may be down on their luck, but they are still a family.

Over his career, giving back to his community has informed his art in ways that are big and small. There are a number of scenes he would not have documented if he had not been supporting an organization. He has eloquently painted both the good times and the hard times of his community to share with and inspire others. As he concluded in an essay titled *Thanksgiving*, "Every man for himself isn't a civilization...and it's fair that we be judged by how those who are most vulnerable are treated in the celebrated, liberating, socio-economic society the rest of us enjoy."[103]

Thanksgiving
Oil on panel
32 x 48 in., 2012
Private Collection

Michener Mules Benefit
Oil on panel
12 x 16 in., 2003
Collection of Roger and
Pattie Stikeleather

Summer Night
Oil on panel
16 x 16 in., 2006
Private Collection

Senegal

"

I couldn't go to Senegal as a tourist. Being among people in great need would overwhelm me unless I knew the work I was doing would help them. I asked Al what could be done to support his efforts teaching surgeons to treat gynecological fistula and prostate cancer, two diseases that are endemic in Africa. He told me equipping an operating room and testing lab would be huge. And it wouldn't take much.

I'm aware of the many good fortunes I enjoy. I wouldn't be in my position without countless people who have generously moved me forward. My worldview holds that we are all in this soup together, and you repay helping hands in kind. I don't have much money—I'm an artist, after all— but I manage to use my art to generate funds instead. Far more than I could hope to give outright.[104]

—ROBERT BECK

Robert Beck is not someone with wanderlust. He likes his home, his community, and his friends, and they supply him with plenty of material to paint. Yet one night in 2010, over a bottle of wine, a urologist from nearby Doylestown named Dr. Albert Ruenes began regaling Beck and award-winning *National Geographic* photographer Bob Krist with stories about his latest trip to Africa, where he performed fistula and prostate surgeries and taught doctors there what they could do to help their patients.

Ruenes had been going to Africa twice a year for six years, and he told tales of performing operations without water, using ether for anesthesia, and a general lack of sanitary environments in which to work. That night the three friends hatched a plan to go to Africa. Ruenes would do his medical work, Beck would paint scenes he encountered, and Krist would make a short documentary, with the goal of raising money for an organization Ruenes had founded called ASSISTS (America-Senegal Surgical Initiative, Surgeons Teaching Surgeons), which was dedicated to treating diseases endemic to African men and women.

"The decision to travel to Dakar, Senegal, was not easy for Robert," Ruenes wrote. "He knew he would be thrust into an uncomfortable environment and was uncertain the effect that would have on his painting."[105] And in fact, in traveling to Senegal, a small nation on the continent's northwestern coast, Beck faced a world that

above
Dakar Night
Oil on panel
12 x 16 in., 2010
Collection of Edward
and Susan Murphy

oposite
Corner Shop
Oil on panel
12 x 16 in., 2010
Private Collection

Robert Beck, Dr. Albert Ruenes, and Bob Krist, 2010.
Photograph by Bob Krist

was far removed from the one he lived in. That presented a challenge. As he put it, "It's good to approach a subject with a fresh eye, but a painter also has to understand the structure and rhythms to describe successfully."

Nevertheless, he knew from his experience with documentary painting that situations are almost always in a state of flux, with light changing, objects moving in and out of the picture, and the weather, in this case involving considerable heat and humidity, interfering with his supplies. Beck took it all in stride. "You roll with it," he said, "because you never know if it is a setback or a gift."[106]

For the ten days he was in Senegal, Beck was on a mission to create a painting essay on the everyday lives lived in that impoverished and struggling country. He painted street scenes, landscapes, and a hospital courtyard in Dakar, the capital city, where the group spent most of their time. Several days were spent inland, and Beck went along, painting in villages where he was left alone by the group as the doctors traveled to treat yet more patients. "The people were generous and friendly, but the culture was different, the rules were unknown, and I didn't speak the language," he said of the experience. "My sense of mission got me through moments of anxiety."

Dakar
Oil on panel
12 x 16 in., 2010
Private Collection

In one rural spot outside the city of Mbour, Beck spent an afternoon painting the village well. When he was done, a farmer beckoned the painter to follow him. "We walked to the well where he handed me a bar of soap, drew a pitcher of water, and poured it on my hands as we crouched under a tree," Beck recalled. "He didn't speak English. I didn't speak Wolof," the native language. "It didn't matter."[107]

During that visit Beck produced a suite of twelve 12-by-16-inch oil-on-board paintings that are marked by the different light in Senegal and are of distinctly African subjects, yet they all seem to be signature Beck works. He had given form to the feelings he experienced in the moment when he was in Senegal, much as if he were painting in the center of Lambertville. The

spirits and the scenes were different, but the intent was the same. "It is said that all art is autobiographical, and it's true that how you interpret depends on your experiences and understanding," Beck once wrote. "I paint parts of a scene that for one reason or another matter to me. If those things overlap another person's experiences and the things that matter to them, we have lift-off."[108]

How much "lift-off" the paintings had was tested about six months later at an event that the Ruenes' organized to offer his paintings for sale and to allow visitors to view Krist's short film to raise funds for ASSISTS. Most of the paintings were sold, and the event was a huge success.

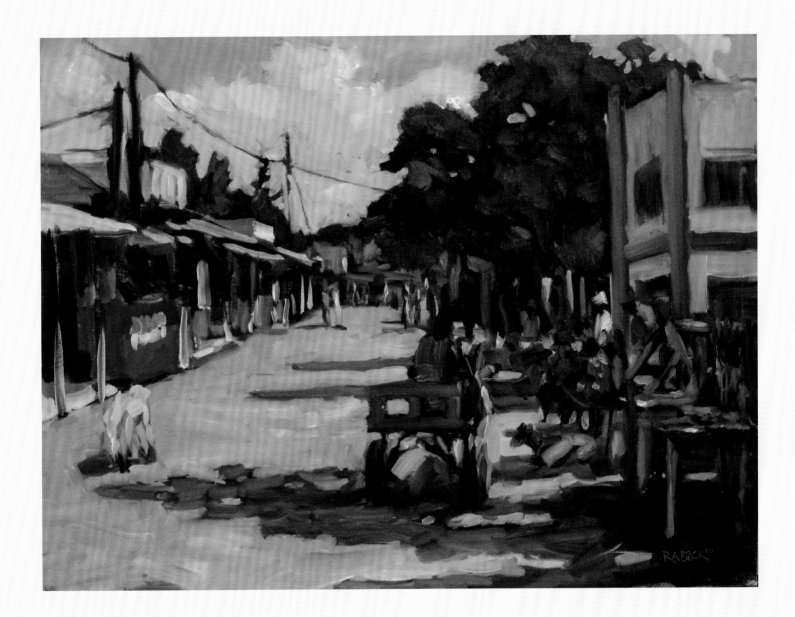

Mbour
Oil on panel
12 x 16 in., 2010
Private Collection

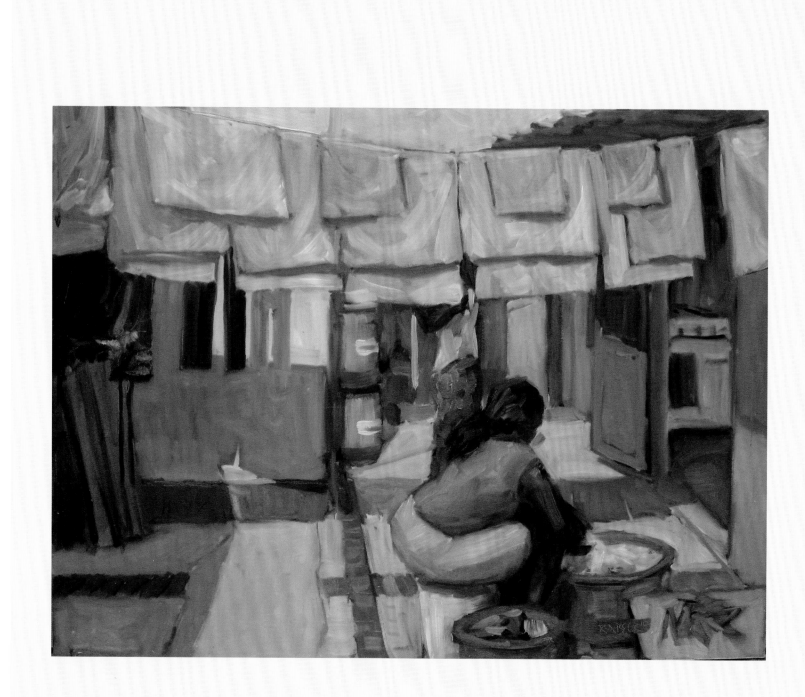

Washing
Oil on panel
12 x 16 in., 2010
Private Collection

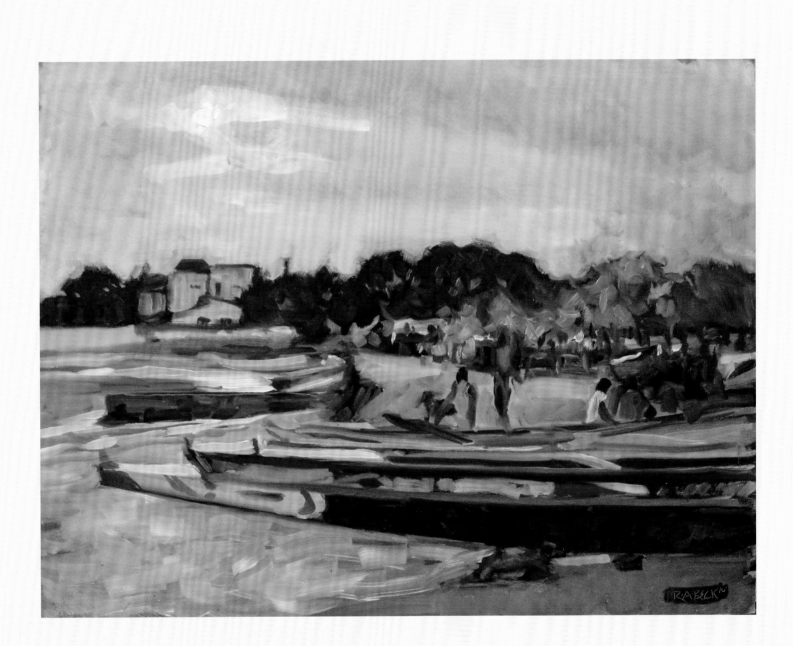

Cooing at the Fishmarket, Dakar
Oil on panel
12 x 16 in., 2010
Private Collection

Over East and Other Directions

Robert Beck likes to challenge himself. Painting from life, often in unusual places, with people milling around, or at a fund-raiser where there is a defined time limit to finish his work, Beck channels the pressure into a focus not unlike the kind he used to apply when he was a goalie in hockey. "I feed off of it, when it's sort of crazy and things are moving fast," he once said. "It's like flying an F-16."[109]

Beck also likes to push the envelope of his work. Beginning with his 1999 show on the American West, he started to include more text to accompany his images. He found that writing allowed him to expand on the paintings, and he challenged himself to try his hand at writing short thematic essays. In the mid-1990s he met a magazine editor named Trina McKenna, and a few years later he decided to send her—unsolicited—several essays he had written about his art and life to get her opinion. In writing these essays he was in effect experimenting in what was a new media for him, and he thought that McKenna, who was the editor and publisher of *Primetime*, a monthly arts magazine in the Philadelphia area, might be able to offer some constructive criticism.

As it turned out, she liked his writing and asked if she could publish some of the pieces. His first essays were short and carried only his byline, but their success led to a monthly column starting in 2005 that included both an essay and an image of one of his paintings. The name of the feature was A Thousand Words, playing off the idea that a picture is worth a thousand words, although the essays were often shorter than that.

The essays covered a wide range of ideas and approaches. Some are "how I got that painting" stories in which Beck describes his setup and imparts painting techniques. These explanations help the experienced artist understand how Beck achieves his results, and for the nonpainter they serve as philosophical metaphors akin to the description of bike mechanics in the celebrated 1974 work *Zen and the Art of Motorcycle Maintenance: An Inquiry into Values.*

It is rare to have an opportunity to learn how an artist makes decisions in their work, especially when it comes to a Realist like Beck. These decisions involve much more than simply choices regarding light, shadows, shapes, and colors. The viewer often assumes that the artist painted what they found. Yet for Beck, "I was painting what it was like to be there," and as a result, and paradoxically, the finished painting looks more like the scene than it did when he actually saw it. In effect, Beck allows us to look over his shoulder as he uses his brushwork to capture an experience, a feeling, or a memory. For the artist, "essay and its image represent two dimensions of the same subject," he wrote. "One goes deep, the other goes wide. The painting relies on the viewer's recollection and experiences, while the writing goes beyond the picture frame and expands the narrative."[110]

The essays also include meditations on art and its power to allow us to see the accompanying painting, and perhaps all art, in a fresh light. Beck has a remarkable ability to articulate complex emotions and relationships in art in a simple,

ICON magazine, October 2011

direct, and occasionally humorous way. He "trims the fat" in his writing much as he does in his painting so that we can see clearly both what is happening and what he is thinking as he works. "Some people aren't interested in communicating things to others," Beck once told a reporter. "I care. I'm a describer. It's why I write. In all of it, I try to pin down a truth. A truth about being in that moment, a truth we can all agree on."[111]

Just as often the essays have little to do with the painting itself; sometimes the act of painting is not even mentioned. Yet because all the essays are paired with images, the columns can serve as subtext to the artwork. Beck's writing introduces readers to men, women—and dogs—that are remembered long after he has come to the end of his story. He reveals the essential elements of who they are and the world they inhabit within the relatively tight confine of the essay form.

"I push to find new means to get an idea across every time I begin an original work," he explained. "I might start an essay before painting, write it afterward, or even during. For me, it's the same event described in different languages. The root of my subject is always a specific encounter, but the work takes direction as it unfolds. My images rarely end as they begin, and the essays are even less tethered to a specific course. That's why the painting might be of a boat, but I end up writing about the dog walking past. It's all very fluid and unpredictable."[112]

Perhaps the subject that he had returned to more often than any other in his essays are stories from his annual solo trips to Maine, regular weeks-long summer sojourns to the Pine Tree State that started at the beginning of the twenty-first century. Beck avoided big towns or in fact any town that makes its living through tourism in search of small and authentic places. "When I'm in Maine I spend a lot of time in boatyards," he wrote in a 2010 essay. "They're quiet places, rich with craftsmanship, history and ghosts, and I can always find a compelling subject when surrounded by the sights and smells of boatbuilding, and the romance and reality of the sea. It's a beauty born of reverence."[113]

Maine paintings began to show up in Beck's self-produced exhibitions as early as 2001 starting with a wooden boat, *Grayling*, being restored in Brooklin, Maine. Each year he settled into one of various small towns along the northeast Maine coastline, "the Down East peninsulas, which stretch out into the Atlantic like long ragged mittens,"[114] as he described the area, to both paint and decompress. Near the end of his 2012 trip, he went looking for a new place to paint as gentrification took over more small towns in the area. He drove on small roads up to Canada and back along the coast and discovered the fishing and lobstering town of Jonesport, population 1,331, more than two hundred miles northeast of Portland. He has returned to Jonesport every year since then.

"Jonesport is a small, interdependent community rooted in the earth and sea," he wrote. "Life can be hard and sometimes brutal, and there are few secrets or pretentions."[115] Here he had found a place where life was lived the way it had been for decades, perhaps a century. The fact that the town had no amenities, such as restaurants, hotels, bars, or even a beach, appealed to him. "I go to Jonesport because there is a truth I don't find elsewhere," Beck declared. "Something about who I am, how I was brought up, and what I've learned. Theirs is a demanding and prescribed existence. Everyone knows each other and needs each other, and in some ways that becomes self-regulating. They show up before the phone rings. They roll up their sleeves."[116]

Having spent his adolescence in a small town, then adopting another as his community as an adult, Beck understood how to get to the center of things in Jonesport. One of the first paintings he did was at the so-called "Liar's Table," a table for regulars at the local variety store, because he knew it was a good way to get the news out about what he was doing in town. Almost immediately after painting the scene, people knew who he was before he walked through the door.

Beck embarked on a series of paintings whose goal was to examine the many different facets of how life is lived in a working town along the Maine coast. He painted fishermen and boat builders, church dinners and lobster boils, all with his distinctive short, sharp brushstrokes and suggestions of

Liar's Table
Oil on panel
16 x 16 in., 2013
Private Collection

it—dictates what's important."[119]

After spending weeks painting all over town, at the end of Beck's first stay in Jonesport a local crab picker asked when she and her neighbors could see his work. In response Beck quickly arranged an exhibition at the local library with the help of a library volunteer. "A large crowd showed up," he recalled. "It was perhaps my most satisfying exhibition. People engaged with the images and talked about them with each other. They saw their world through my eyes, and they understood that the paintings were a celebration." By becoming a familiar face in town and by working beside the residents in the same weather and "getting the same stuff on my boots," he had been accepted into yet another tight-knit community.

details. One critic described his handling of paint as "deliberate and energetic, giving the painting an intimacy rich with layers of lived history." The review continued, "Most of Beck's outdoor scenes are shrouded in layers of fog so thick that you can almost feel the mist of heavy sea air on your face, whereas the interiors are filled with light and warmth."[117] The artist saw Jonesport as a "place that dwells on a seam between the past and the present," adding, "The lobstermen use contemporary navigation electronics in their boats, but bait is still packed in a bucket and lowered by a rope from the wharf as it has been for a hundred years."[118]

Life centered on fishing. In the community's pace, common understanding, and heritage, similar to some of the other small towns in Maine that wind along the coast south of Canada, Beck found similarities with West Virginia coal towns and Kansas farm communities. "The proximity to nature—the beauty and the harsh reality that comes with

Beck returned to Jonesport year after year, made friends with local residents, and in the process learned their stories. Beck painted boats going out on foggy mornings and ships, heavy with their catch, coming home at the end of the day. Some of these paintings were larger panels created in his studio, based on the plein air works he had done in Maine, so that Jonesport stays with him even when he is back in Pennsylvania. In his essays he introduced readers to characters who had never left the area and were doing what their grandparents had done, boat-building history, family stories, and dogs (dogs have always played a role in Beck's life, steady companions that have been the subject of paintings and essays).

"For twenty years he has been quietly observing the small moments of life in Jonesport and other rural, coastal Maine communities," wrote Amy Lent, the executive director of the Maine Maritime Museum, when the museum mounted

a show of Beck's Maine work in 2016. "He translates those observations into images that tell a story—and he does it as the best artists do, by finding and capturing the spirit of the scene so the viewer doesn't just see the moment as represented on canvas, but also feels it."[120]

Beck discovered that "engaging a subject more than once gives you a chance to show what you learned the first time, but comparing the way it looks over time teaches you what is constant and what is ephemeral."[121] His commitment to painting the area grows deeper with each year. Other than the Lambertville–New Hope area, he has painted no place more than Jonesport, and the paintings and essays continue to pour forth. One can draw comparisons to the work of many artists who have been attracted to and painted in Maine over the years, but not surprisingly, Beck found a way to create his own pictures on his own terms.

"I don't separate being an artist from the rest of my life," he explained. "When I choose to do a series based on a subject, it is to grow both as a painter and a person, to better understand the world around me and finely hone my method of describing my response. The subject has to excite and hold me."[122]

Beck relates to the "part of the larger story of life on the coast," adding, "Take it as it comes, work hard, work together, and figure out a way. Pitch in, because someday you will see that person on the other end of your rope."[123] At the same time he wonders how long this way of life can last. He wants to document the events, occupations, and artifacts of our time, but he understands that inevitably things will change and perhaps even disappear. In a 2003 exhibition on American farms, he asked, "Of all the places and things we are familiar with today, which are going to be the same five or fifteen years from now? Have you tried to find a pay phone lately?"[124]

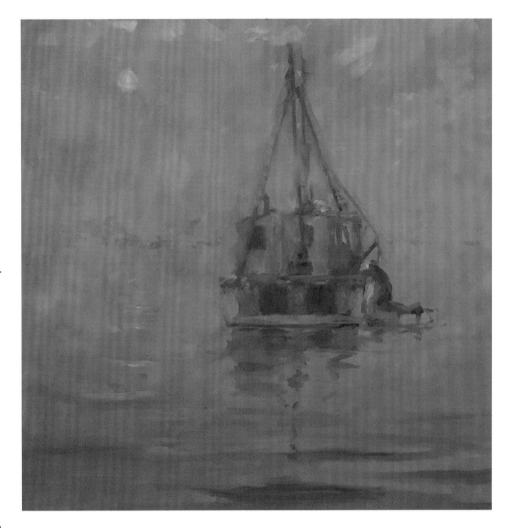

Back Fog
Oil on panel
16 x 16 in., 2017
Collection John and
Elise Rupley

Beck feels the same concern regarding Jonesport. His paintings record life in the village now, but already his images have become valuable visual documentation of a way of life that is inevitably vanishing. "Each visit comes with apprehension of what the future has in store," he admitted. "Many places were like this once. Our world is diversifying and homogenizing. Values are changing. In many respects we are better off for it. But when I compare a society where productive knowledge and skill gets passed directly from parent to child against one where change comes so fast that generations barely understand each other's language, I'm drawn to the humanity rather than the technology."[125]

Soundings (The Bell)
Oil on panel
18 x 18 in., 2005
Collection of Howard Leister

Stanley Beal
Oil on panel
16 x 16 in., 2013
Collection of Jean Wilson
and John Roberts

Hauling Out
Oil on panel
24 x 24 in., 2015
Collection of Maine
Maritime Museum

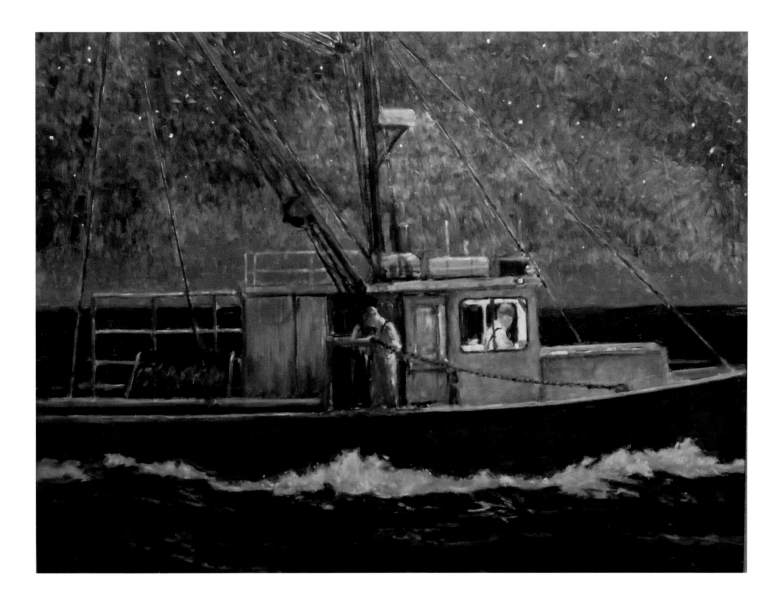

4 am Off Great Wass
Oil on panel
24 x 30 in., 2017
Collection of Bridget Wingert

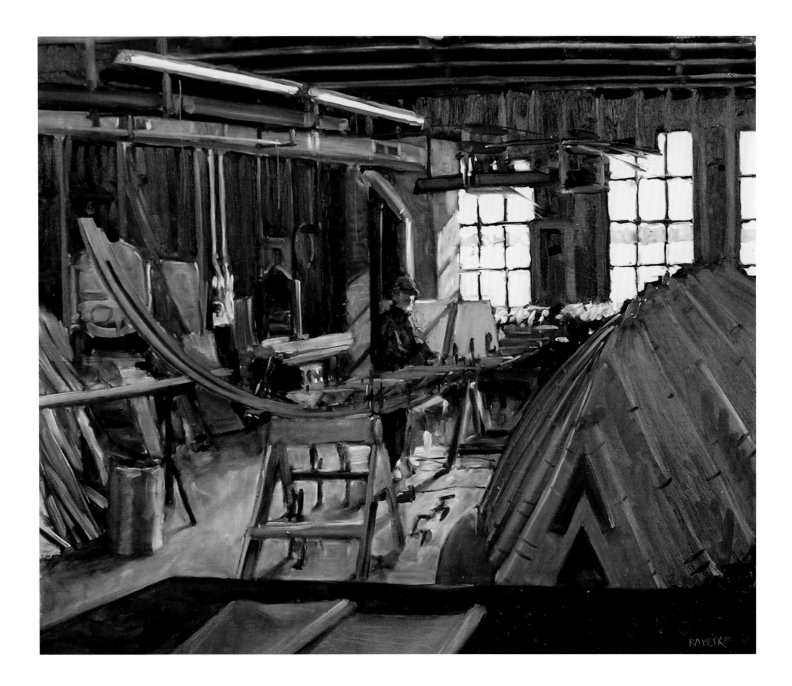

Charlotte's Sister
Oil on panel
20 x 28 in., 2006
Private Collection

When Beck visited this boatbuilder, they were launching a boat called the Charlotte based on the "flatfish" designs created by wooden boat designer Joel White, the son of E.B. White of *Charlotte's Web* fame. The sister ship shown in this painting was to be called Serena from a character in E.B. White's book, *The Trumpet of the Swan.*

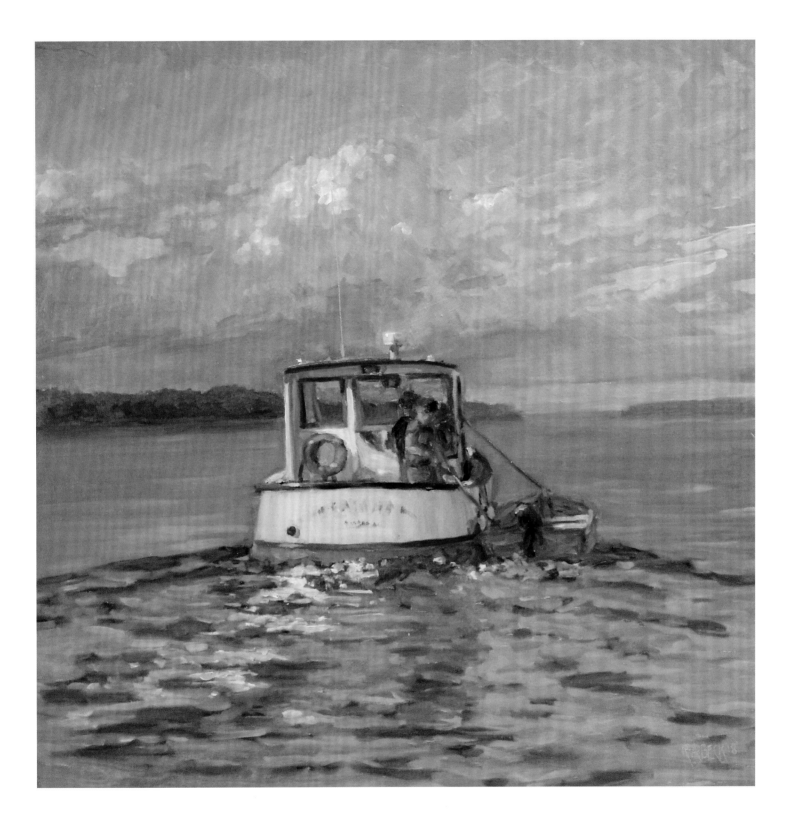

Tatiana
Oil on panel
14 x 14 in., 2018
Private Collection

New York, New York

Robert Beck was born in northern New Jersey, in the shadow of New York City, and as is the case with many people, his roots are in the city. His grandfather was born there in the 1800s in the East Side neighborhood known as Turtle Bay, which at the time was packed with breweries, gasworks, slaughterhouses, cattle pens, coal yards, and railroad piers but is now the home of the United Nations. His grandmother lived in a Midtown tenement. His mother was from Brooklyn, and she met her future husband when they both worked at the Irving Trust Company at 1 Wall Street.

Beck remembers as a child going into the city on special occasions such as school field trips or for holiday shopping. When they'd visit his mother's family around the holidays in Brooklyn, he remembered crossing the George Washington Bridge and heading "down the West Side, where we'd pull off of the elevated roadway and drive along the docks. It was a third world to me. Not the trees, grass, and color of my hometown, and not the glass and granite upward energy of the city, but a colorless, gritty industrial landscape secreted between the 'highway' on one side and the piers on the other. All paving and rust."[126]

But after his family moved to Chalfont, Pennsylvania, trips to the city were rare. "I grew up in rural Bucks County, and New York seems an anomaly," he wrote in an essay, "a great hive built to compress and concentrate human activity, a fortress against things natural."[127]

Beck's first painting of the city was actually painted in Bayonne, New Jersey. In the days after the terrorist attack on the World Trade Center of September 11, 2001, he felt a powerful need to document this devastating moment in time. "I went up to New York two days after the towers fell," he recalled, "and did a painting of the skyline from a wharf in Bayonne because that's what I do."

That work, *Lower World,* a roughly painted, highly impressionist scene of lower Manhattan, captures some of the emotions Beck was experiencing along with the rest of the nation. When it was included the following year in an exhibition at Princeton University titled *After September 11,* he noted that "from that distance there was a great quiet."[128] Seven months later Beck returned to Liberty State Park in New Jersey to paint the *Tribute in Light,* an installation of two columns of light intended to represent the World Trade Center and one that is now an annual event. But the tragedy of the attack still haunted him.

"I couldn't shake the image of the remains of the Trade Center facade I saw in a magazine," he explained. "It was always at the edge of consciousness whatever I was doing, demanding consideration. So I painted it, for no reason other than to say the name out loud and banish the demon stowaway. I didn't plan; I just painted."[129]

Beck's response to the attack, titled *Vestige,* was an ethereal twenty-by-twenty-four-inch oil of the exoskeleton of one of the buildings. "When it was done," Beck wrote, "I

Lower World
Oil on panel
16 x 22 in., 2001
Private Collection

Vestige
Oil on panel
30 x 24 in., 2002
Private Collection

Mother Goose
Oil on panel
12 x 16 in., 2008
Collection of Cindy
and Al Ruenes

saw the resemblance to Brueghel's *Tower of Babel*, and wondered whether that was one of the connections that made it so difficult for me to ignore."[130] Although this was a studio work, he painted it in one sitting as something akin to an exorcism. When exhibited at Princeton, the painting had the same effect on many viewers, giving form to a feeling that they could not fully articulate.

"Civilization's most important invention is language, and the visual kind is very potent," Beck wrote in discussing the work. "With flexible grammar and a nearly limitless well of symbols, art can deliver a succinct idea that would otherwise collapse under the weight of words. Finding that perfect image among the vast possibilities that are not so perfect is a labor. Artists need to do it because that is how they interact with the world. Often, it's an itch they can't scratch, but that doesn't stop them from trying."[131]

In 2001 Beck met Doreen Wright, who visited his studio with a friend. Wright subsequently commissioned a triple portrait of herself along with her two daughters. In 2004 the friendship developed into a personal relationship at the same time Wright purchased an apartment on the Upper West Side, and Beck began visiting the city regularly. During the renovation of the apartment, Beck was instrumental in designing some of the interior design elements,

including a large wall mural. Other Bucks County artists were invited to create installations, such as railings, leaded glass, and decorative surfaces.

Unlike the way he responded to Bucks County or Jonesport, Beck did not find an instant community connection to either the Upper West Side or Manhattan itself. "I still paint New York as an outsider," he told a reporter in 2008, "and there is the taste of my documentary works in those images. They probe. The image of the Mother Goose statue [in Central Park] is more about the moment I came across it than the monument itself." He compared the painting to his Bucks County work. "There is a more relaxed intimacy to my scenes from along the river because that's my home. The sycamores are old friends."[132]

For a painter who finds working at night exciting, New York provided a wide range of scenes to paint. "City lights can seem to go on forever," Beck once wrote, "but that sphere of reduced awareness still applies. During the day you consider the next block or two but at night the next thirty feet. Things emerge suddenly. There is immediacy in the air."[133] He painted Carnegie Hall at night, aglow with anticipation of the next performance. He captured traffic flowing down Sixty-sixth Street from the twentieth floor of a building on the West Side. He captured a ferry on the East River bringing home working men and women at the end of a day.

NY Mural
Oil on nonwoven poly fabric
96 x 120 in., 2006

He spent more time in the home of the Ashcan school, and while he adhered to their direct style of painting, their darker palette, and their gestural brushwork, instead of depicting scenes of the residents of the city's poorer neighborhoods, Beck's own Urban Realism included the aristocracy at the upscale L'Absinthe restaurant, scenes inside the exclusive Players Club, and the many faces of Central Park.

No matter where Beck went in the city, his painting was never far from his mind. Once while waiting for a subway train, he started to daydream to escape the scene. "I was standing on the platform at the 66th Street station on the 1, bathed in a pungent New York cocktail of exhaust and decomposition, studying the light that filters down from the Broadway sidewalk grating onto the girders and rails, wishing I was in some other place," he remembered. "A place without track announcements, roaring blurs of windows, strangers clinging to chrome pipes, rocking against each other. A place where I could watch the sun rise and set and focus my eyes on a point more than two blocks away. A place with no gray, save for the nightly fog off the ocean that makes sure things don't begin to move too fast. Like Maine, perchance. If a lobster boat pulled up right

Subway
Oil on panel
24 x 30 in., 2016
Courtesy of Morpeth
Contemporary

Carnegie Hall
Oil on panel
24 x 30 in., 2015
Private Collection

then and there I would hand my suitcase to the captain, release the lines, and take a heading northeast."

Beck let the idea marinate in his mind and eventually committed the fantasy scene to a large panel. "My way of translating thoughts into a two-dimensional image begins with a couple of small doodles so I can determine shape and scale, but most of the investigation takes place on the painting surface," he wrote in an essay about the painting. "It's oil paint; I can move things around, wipe them out, try this or that. Art is happening until the artist makes the last choice or gamble that affects content."[134] The finished work, simply titled *Subway*, depicts a real subway station with a real lobster boat sailing on the tracks.

Beck also continued to paint around town, strapping his painting kit and easel to a small hand truck to make it easier to get about. He and Wright married in 2012 and split time between New York and their Solebury home. Beck rented a studio not far from the Manhattan apartment, in a building that housed art studios in the Robert Henri and George Bellows era, which Beck refers to as "A place with good ghosts." There he concentrated on easel paintings that were larger than his documentary images. After painting a snowstorm the previous winter, in 2015 he "had time to consider what was right in that painting and what I left on the palette." And he added, "I felt there was more to be had, so I decided to address the subject again in a different fashion." In an essay for *ICON* magazine later that year he detailed what he was thinking when he composed the work.

66th Street
Oil on panel
20 x 12 in., 2007
Collection of James
and Gail Schwarz

It's one thing to suggest snow with cartoonish speckling of white, but another to have the viewer's ankles go cold from spontaneous recall. You identify a snowfall by how it occupies space, alters light, and diminishes visibility. You don't see it through a curtain of dots. That atmospheric effect was my goal for the painting. I experimented with Flake White, a pigment that has a transparency to it, along with my usual, opaque Titanium White—the first time I worked with two whites on my palette. The color of my grays was also important, as well as the calligraphy of the brush strokes.

There were triggers woven into the image. In addition to describing the blizzard's intensity I wanted heartbeats: the guy shoveling, the dog walker, the woman hailing a taxi, and so on. It's important that figures have iconic gestures created for a purpose so that the scene does not appear as a stilted duplication of what was happening at the moment some photo was taken. Snapshot gestures and bad anatomy detract from a good painting. Plus, opportunity is lost. The figures have to diminish in size and visibility at the same rate as everything else; otherwise they will look pasted on. When placing objects in the image I avoided even numbers, even

Blizzard
Oil on panel
24 x 32 in., 2015
Private Collection

spacing, or symmetry. Those things do occur in real life, but you have to be in a specific place to see them and that ties the viewer down. I want things moving...

The woman has a fur-lined hood, and the cab carries one of those tall advertising boards on the roof, but neither compromise the timelessness of the statement. If they felt out of place, I would have changed them (they were invented, anyway). Each element has to earn its place in honing the impression or it gets removed. Everything in the painting is where it is on purpose, in terms of both the larger composition and its contribution to the narrative. Your eyes didn't end up on the woman's hand silhouetted against the taxi advertisement by accident.[135]

Like his Urban Realist forefathers, Beck paints a scene that is different from an Impressionist snow scene that might have depicted an imposing view of a major avenue. Although Beck had narratives in his own mind, a viewer looking at the painting does not detect anything narrative, anecdotal, or prettified about the image. Beck's snow is more gray than white, and the composition reveals an essentially Realist view of snow in the city.

Empire
Oil on panel
24 x 30 in., 2019
Courtesy of Morpeth
Contemporary

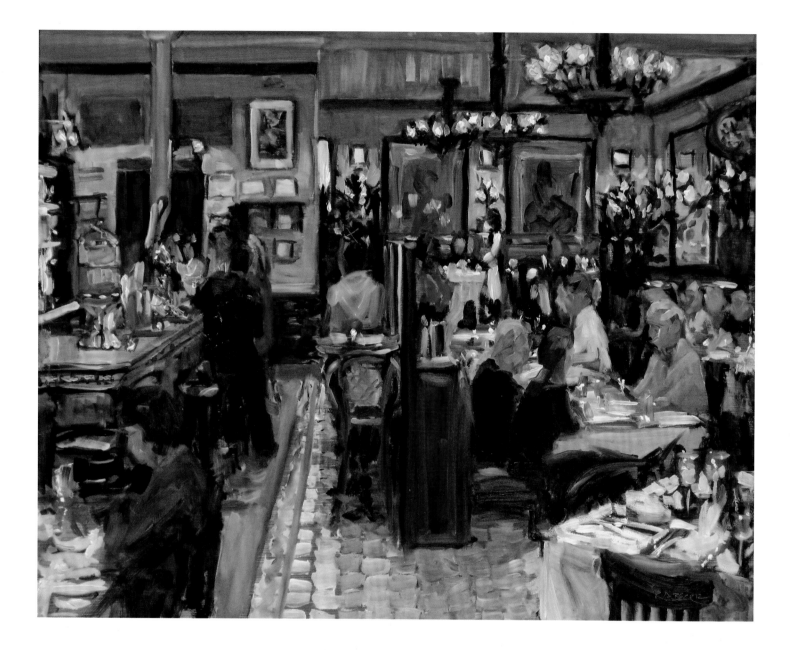

L'Absinthe
Oil on panel
16 x 20 in., 2012
Collection of Jean Wilson
and John Roberts

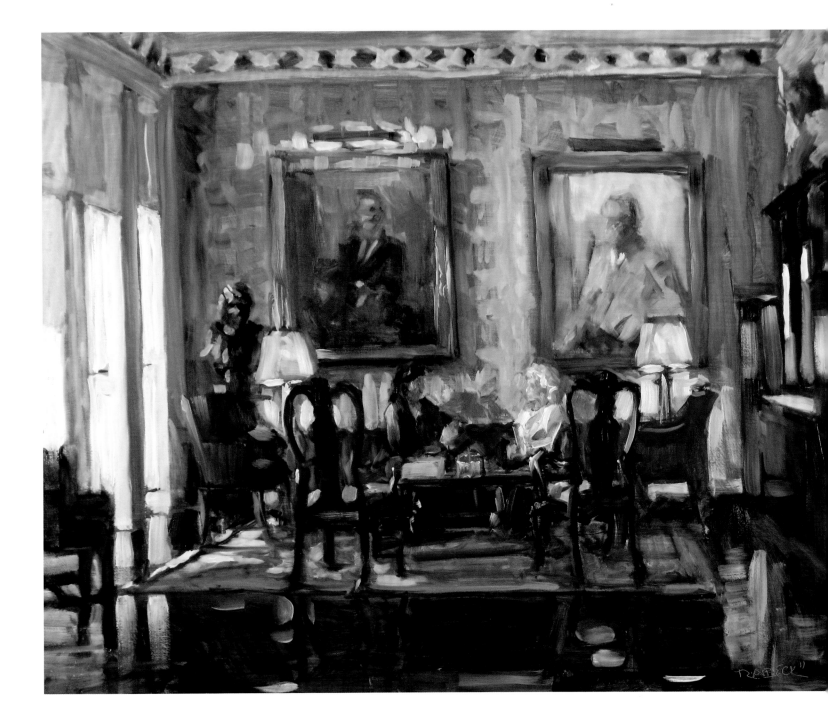

Conversation
Oil on panel
16 x 20 in., 2011
Private Collection

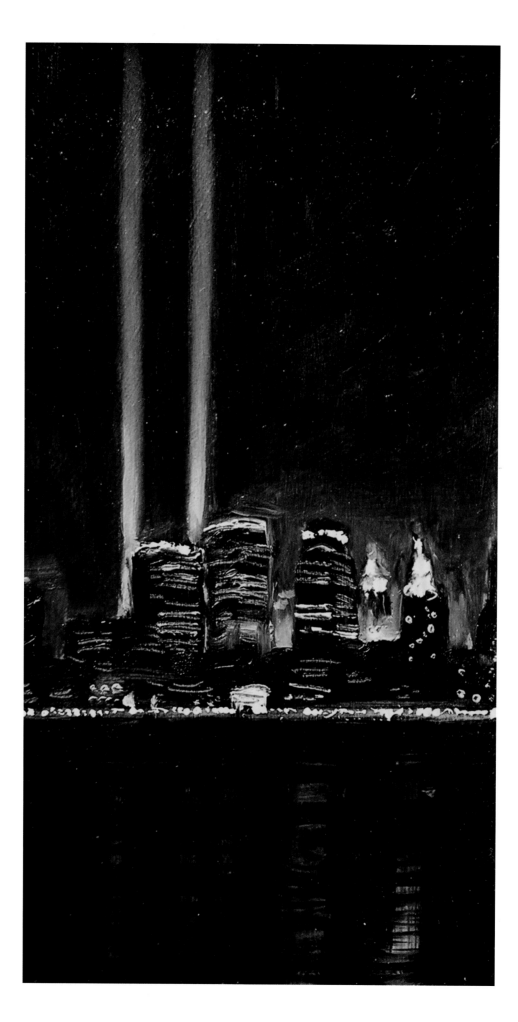

Towers of Light
Oil on panel
9 x 5 in., 2002
Private Collection

Iconic Manhattan

"

When I do a topical series I select diverse subjects that contribute to a larger description. I want a variety of moods, views, and times of day, but when I arrive to paint I'm only concerned with capturing the iconic image of that place, not how it will compare with other paintings in the body of work. Above all, I want to make a good painting that describes the encounter. I do a quick reconnaissance and see what memory comes up as my mental title page for what I saw, and that's my target.

—ROBERT BECK

"*When I begin painting I look for the elements that triggered that original impression, and I either simplify or eliminate other things that distract. I might keep specific details like telephone lines because they support the sense of place, but portray objects that are peripheral to the idea in a more loose and suggestive way. I want to balance the voices to get a clear but full description of my encounter.*

There are also things that happen while I'm standing for three or four hours painting my subject that help me understand what I am trying to depict. I see rhythms, changes and other occurrences that add to the identity of a place, and I get to sample the people who come and go to create gestures that fit with how it feels to be there.[136]

—ROBERT BECK

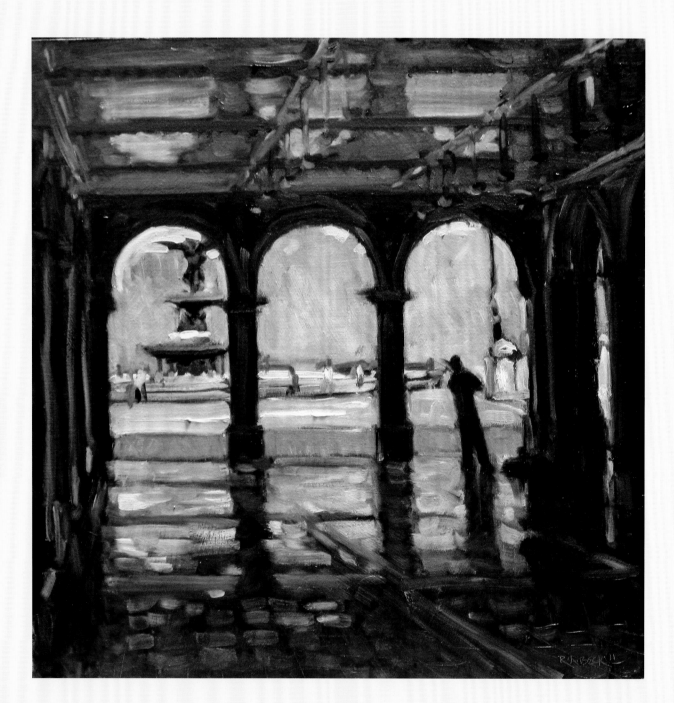

ny artist who paints Manhattan is aware of the generations of painters who came before them, and the awareness can be humbling. The city is rich in iconic imagery, historic architecture, and colorful characters, all of which can inspire, or in some cases intimidate, an artist. Robert Beck had been painting New York City for more than ten years before he had his first solo show there.

Beck displayed some of his Central Park paintings at his Lambertville studio, where they were seen by Joyce Chasan, a Park Avenue art gallerist who arranged an exhibition hosted by the historic National Arts Club on Gramercy Park South in 2012. That exhibition, titled *Iconic Manhattan,*

would in some ways bring Beck full circle with the Ashcan artists, as they had exhibited in the same rooms at the club in 1904 as their introduction to the New York art world. For years Beck had quoted the rebuke of John Sloan to artists about painting "pretty pictures." In the exhibition catalogue he begins his "Forward" referencing the group's leader. "Robert Henri, the father of the movement, encouraged his students not to paint what was in front of them, rather to paint how they felt about it. Expressing your response to a subject is at the heart of art. Duplication means little."[137]

In this thirty-one–painting pictorial essay, Beck ranges from a snowy scene at the Bethesda Fountain in Central Park to a warm and comforting work called *Conversation* that is set at the Players Club, which sits facing

opposite
Arcade Violin
Oil on panel
12 x 12 in., 2011
Collection of
Meg Brinster Michael

above
**Central Park West
Beginning Snow**
Oil on panel
12 x 16 in., 2011
Courtesy of Morpeth
Contemporary

Gramercy Park. Bucolic cityscapes of Central Park in various seasons share space with sun-filled interiors of the National Arts Club, busy sidewalks with the solemnity of the Steinway Piano showroom, and the Lincoln Center subway station with rooftop scenes of the Neo-Gothic Woolworth Building in Lower Manhattan.

In Beck's painting of the rarely opened Edwin Booth bedroom at the Players Club, the rendering is so evocative that one can almost smell the tobacco that once suffused the room. In an image of the arched interior walkway in the Bethesda Terrace Arcade in the center of Central Park, a study of light and shadow suggests a violinist in silhouette. "Manhattan is a huge topic," Beck wrote in the exhibition catalogue, "larger than any exhibition or artist, and I made no effort to include a balanced cross-section in this show, whatever that might be. This body of images represents the opportunities that opened before me in this most special place, and how it felt to be there."[138]

Woolworth Building
Oil on panel
16 x 16 in., 2011
Private Collection

Edwin Booth's Bedroom
Oil on panel
16 x 16 in., 2011
Private Collection

Subway
Oil on panel
12 x 16 in., 2012
Private Collection

Snow Bridge
Oil on panel
12 x 16 in., 2009
Collection of Bill Goldman

House and Home

"Sixteen years ago I moved to the New Hope–Lambertville area," began a letter to the editor in the *Bucks County Herald* in May 2012. "I was starting a new career as an artist and needed to be part of an art community if I was going to make a go of it. In time I was able to support myself by painting, due largely to the kindness and encouragement of many people, some whom put considerable effort into helping me forward. This place has become my home, and the friends I've made, my family."

In this letter, Robert Beck was writing to thank all the friends and neighbors who had wished him well and/or come to New York to see his exhibition at the National Arts Club that spring. While he acknowledged that a solo show in Manhattan was a milestone in any painter's career and was delighted by the nice things New Yorkers who visited the exhibition had said about his work, "the best part of this whole experience," he continued, "has been having with me in spirit all those who wrote, came to the show, or who have been part of this wonderful ride for the last decade and a half."[139]

By this point in time Beck had not only found his home, he was again a homeowner. After years of renting the Tree-house in Lumberville, he and Doreen Wright had decided have their own home together in Bucks County, and when they could not find something that fit their needs, they decided to build a home for themselves. They picked a two-and-a-half-acre wooded slope in Solebury, a Bucks County community just west of New Hope, and Beck started to design a home for the site.

"It is curious that when I was young my doodles often were floor plans,"[140] he remembered. "Like a lot of kids, I would do drawings of cars, boats and planes, but I wouldn't stop with how they looked. I also drew the inside plans for using them, like seating, storage and controls. I did houses too."

Inspired by Frank Lloyd Wright's Prairie style and by Craftsman and Japanese architecture, Beck created a design that architect Michael Raphael turned into working drawings and builder John Zerrer made a reality. Beck designed specific elements of the house including a grand mahogany front door[141] inlaid with handcrafted leaded glass by Bill Osler and Kim Kurki,[142] a fireplace with a mantel by Mira Nakashima, and trim details that visually eliminated edges. He asked his artist friends such as Joseph Crilley,[143] Robert Whitley,[144] and Katherine Hackl[145] to create works in their own mediums based on the theme of branches for more than twenty small niches throughout the house.

Beck also designed his studio on the property. "A studio is not a den or a workroom," he explained. "It is part of the artist's anatomy—the exoskeleton—protecting here and flexing there. A space like that is the dream of every artist working at the kitchen table."[146] Beck placed his studio steps away from his home, above the garage, and in the process re-created the best aspects of his Treehouse home and studio while giving himself a comfortable multilevel workspace where he could address all aspects of his art. Not surprisingly, Beck painted a series of works documenting the construction of the home but also spent considerable time away from his easel to work with the construction team. Upon its completion in 2009, the home won the award for residential home design from the Bucks County chapter of the American Institute of Architects.

Beck also continued to find new ways to connect with an audience in his community. In the fall of 2008 he began hosting a weekly two-hour interview program called *The River* on WDVR-FM, a community radio station in Sergeantsville, New Jersey. Just as painting unusual subjects offered Beck the opportunity to meet people he might not have come across when painting traditional landscapes or working in his studio, Beck invited guests from an eclectic range of professions to learn more about what they did. His guests included a former Secretary of the Navy, an executive producer at ABC News, and the general manager of the New Hope & Ivyland Railroad.[147]

Beck enjoyed himself, but by the end of January 2010,

Framed
Oil on panel
10 x 16 in., 2008
Collection of John Zerrer

with his house completed, he wanted to recommit to painting full-time. "I was being as creative as ever, just putting it in another direction," he told a reporter. "The different approach to form, space, proportion and rhythm [in designing and building a house] sharpened my visualization skills and made me a better painter. It was also an opportunity for me to look forward. I'm 59—a good time to take a clear fix on the horizon and let 'er rip."[148]

The arts community was also changing. Riverrun Gallery, where Beck had first worked in Lambertville, closed in 2009, just a year after its founder, Grace Croteau, died. In 2008 Beck found a new home for his studio/gallery in town, moving his operations to 204 North Union Street. There he expanded his space to present exhibitions of his own work and offer classes taught by himself and others. Since he began teaching in the mid-1990s, he felt that it was important to continue to foster and educate artists of all ages. "This is a pass-it-on-type thing,"[149] said Beck, who frequently taught

two advanced painting classes and a drop-in figure study class a week for over a decade in Lambertville.

In March 2010 his painting *Securing the Long Boats* was featured in an exhibition titled *Now & Then* at the Gratz Gallery in Doylestown, which paired early-twentieth-century Pennsylvania Impressionist paintings with recent works by artists from the same area to show the clear lineage between earlier artists of the region and a group of contemporary artists.

When entering the gallery, visitors faced two striking winter riverscapes from two different centuries. Beck's scene showed the replica boats being prepared for the annual re-enactment of Washington crossing the Delaware. It hung next to Charles Rosen's *Delaware Thawing*, a large 1906 landscape that the artist had painted soon after settling in New Hope. Though separated by more than a century, both works used vigorous brushstrokes to convey the coldness and desolation of the scene. Though divided by time, the two artists nevertheless shared a tradition of painting inspired by the same landscape and being part of the larger

Securing the Long Boats
Oil on panel
24 x 30 in., 2010
Collection of Diana and
Jim Resek

community of artists of the area.

"Whenever I set up to paint, I say, 'Where do I start?'" Beck said at the time. "I used to think it meant I wasn't a painter if I didn't know where to start. Now I accept that as the challenge. And each painting comes with a story. I look at a finished painting and I remember the process and that's the enjoyment for me. When I'm done, the painting is a record of my journey."[150]

His journey was also one for his audience. "The main thing his followers have known about him all along is that he *is* the art," one critic wrote. "His paintings are the equivalent of pages of his own personal journal. Experience a body of his work, and it's as if you've walked with him through his day seeing his world through his eyes."[151]

Beck's path continued to take him new places. In 2011 he painted a series in Philadelphia for a show for the city's prestigious Rosenfeld Gallery titled *Philadelphia Heartbeat*.

In the exhibition catalogue, Richard Rosenfeld, the gallery owner and director, wrote, "Sometimes Beck refers to himself as a documentary painter. Realistic accuracy is a powerful element in his work, but the term documentary suggests an objectivity, a detachment that belies what he does. Rather his works depict how he feels about a particular place at a particular time using great finesse in not crossing the line into expressionism and violating verisimilitude."[152]

Between 2004 and 2012 Beck traveled to Africa, Europe, and England multiple times, resulting in both plein air and subsequent studio paintings of Italy, Belgium, London, Wales, France, and Senegal. It was a welcome, temporary, shift of focus. He is not a comfortable traveler, and he turned his discomfort into strong paintings. Beck returned sharp and energized.

Subjects, even whole series, could come from anywhere. Beck had often started his day in Lambertville getting a cup

of coffee at the coffee shop and buying an item of produce, which he would paint when he returned to his studio. There were chestnuts, kiwifruits, and mushrooms, among other items, and on the back of each small oil he taped the receipt for the purchase. In 2015 he presented these paintings in a special show, *Pantry*, to benefit Fisherman's Mark, food pantry and social services agency.

The following year the Maine Maritime Museum organized an exhibition titled *Over East* that included more than fifty of Beck's Maine paintings. This represented the first time that these paintings, the longest series of his career, had ever been exhibited together. In the show's catalogue the paintings were interspersed with essays Beck had written about Maine, text portraits to accompany the documentary paintings he had created.

The historic Phillips' Mill exhibition, the same show that had been presented annually since William Lathrop's time, was the most important exhibition for artists of the region. Beck had first exhibited there in 1993 and had a work accepted seventeen times over twenty-six years. "I have always submitted what I considered to be my best available painting to Phillips Mill each year," Beck said. "Often that meant it wouldn't be in my own annual exhibition on opening weekend. The Phillips Mill show is that important."[153] In 2017 Beck was selected to be the year's Honored Artist, a recognition given to a living artist whose work has been accepted for the show over a significant number of years.

The decade had seen many other awards. He was given a retrospective at the Museum of Trenton at Ellarslie in 2007, awarded the Philadelphia Sketch Club Medal for Contribution to the Arts in 2014, and named New Hope Arts Legacy Artist in 2018.

Over time Beck has gravitated to studio painting. Freed from the severe time and location constraints of his plein air work, his studio paintings were typically larger and more complex. "Unlike when I paint from life, I can take time to consider what elements suit the content and how to arrange them to best tell the story," Beck wrote in a 2016 essay. "Instead of describing what is in front of me, I'm refining what caught my attention, and what left its mark on my memory.

top
Heron (Academy of Natural Science Philadelphia)
Oil on panel
16 x 16 in., 2011
Collection of Mike Holmes

bottom
Duomo
Oil on panel
8 x 8 in., 2012
Private Collection

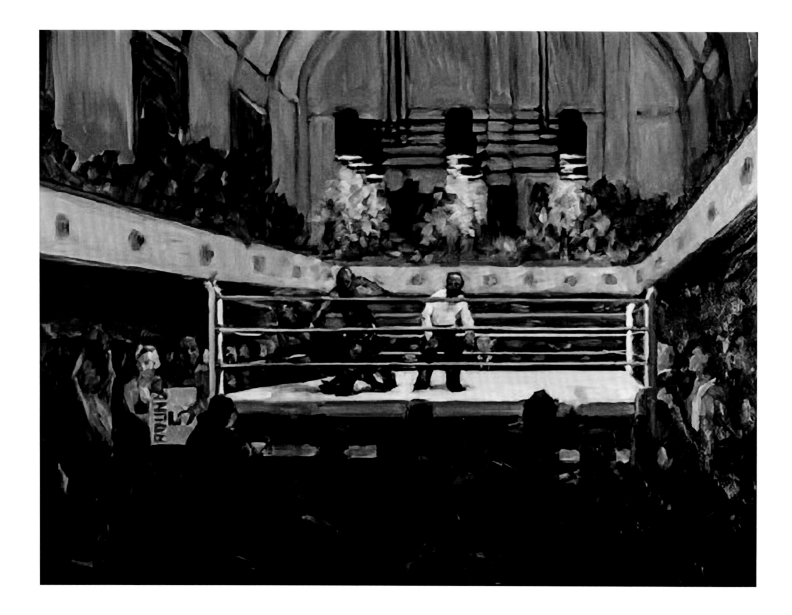

Blue Horizon—Memory
Oil on panel
18 x 24 in., 2002
Collection of Diane Cribbs
and Arthur M. Mann

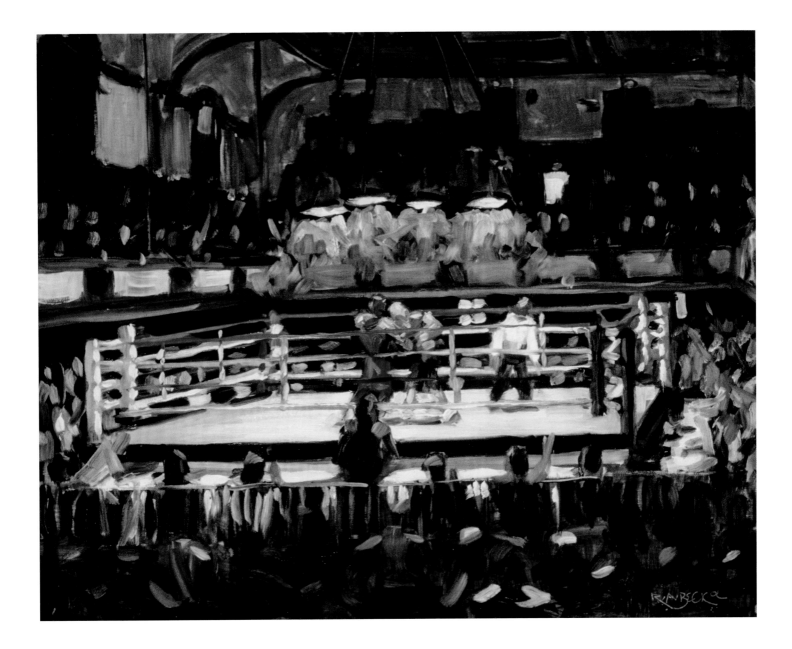

Blue Horizon Live (The Blue)
Oil on panel
16 x 20, 2002
Private Collection

One method has the voice of a play-by-play announcer, the other that of a storyteller."[154]

Sometimes his studio work continued exploring ideas and compositions he had first encountered when painting from life. For instance, in 2003 Beck's friend David Rago invited him to join him at a boxing match at the Blue Horizon, a historic boxing venue in Philadelphia that was known simply as "the Blue." It was a scene that Ashcan painter George Bellows would have relished: two men fighting for sport in front of a crowd whose members were simply interested in a good bout. Although Beck isn't a fight fan, his essay on his boxing paintings, "Last Right," eloquently tells the story of his visits to the Blue.

After having had such a memorable experience on his first outing, he painted the scene from memory the next day in his studio. He knew he also wanted to paint it live and so returned to paint a fight in action. "Many of the things I do scare me," he wrote to Rago, who helped him get permission to paint at the boxing club. "The Mississippi trip scared me. The trip out West scared me. The Blue scared me. But that is when I am the most aware, and when I grow."[155]

Not long after that, Beck returned to the theme of a boxing match for a studio painting that is an effective summation of all he had seen and experienced. For him, the three paintings on the same subject were from different perspectives. "The one done from memory was what it felt like as a spectator, and the one done from life was my response as a painter," he explained. "The large painting that I did later by referring to the first two is not either or both of those things but the place where they intersect."[156]

More recently the artist returned to portrait painting. In 2017 he painted Robert Schoenberg, the founder of the University of Pennsylvania LGBT Center, where the portrait was hung. In 2020 he painted Pop-Pop Heath, a fixture in New Hope and Lambertville who voluntarily films school sporting events, performing arts, and graduations, producing more than two thousand videos a year for community members. Beck's

Last Right
Oil on panel
24 x 32 in., 2002
Collection of
Suzanne Perrault
and David Rago

Eventide
Oil on panel
24 x 30 in., 2008
Collection of
Doreen Wright

portrait of Heath, depicted in his street clothes with a simple pencil in his pocket, hangs in New Hope High School. The artist asked that the work not be hung in the trophy room but rather in a common area where students who saw it could realize that a person didn't have to have some extraordinary talent to make a difference in a community.

Over the years Beck has used his art to communicate with whatever community he was a part of. "I have a great respect for the power of art as a language," he once wrote. "You can take an image to Oslo, Osaka, or Omaha, and people will understand it the same, because the visual language is built on human experience, not dialect or syntax. Art is a language that is unique to the artist but can be understood by everybody, and that fascinates me. I love figuring out what happens in that space between."

Despite all that Beck has done at this point in his career—he is now seventy years old—he still looks for new challenges. "As I get older the territory changes, and my work adjusts to the contour of my life," he explained. "There is no road map. I couldn't have guessed I'd be where I am, and I don't know what's next. I don't want to put myself somewhere. I want it to unfold in front of me. That has worked so far. Still, you have to encourage opportunities to emerge, so I make sure every project includes something I don't know how to do, requiring discovery and stimulating growth. It can be as complex as trying to convey a subtle feeling, or as simple as using a new kind of brush. That's what's at the heart of my work. The things I learn."[157]

"*Skating Party* is a special painting, the kind that happens maybe once a year," wrote Beck to a fellow painter. "Many people think an artist (talking about myself here) comes up with a great idea, sets out his materials, and constructs it as you might a house. Design it, then build it. Some artists do chart a path through drawings and sketches, but I find my way while doing the painting itself. It's how I maintain the energy...I have a feeling, or sensation, or a concept, and I'm searching for the imagery in my personal experience that will trigger that feeling in others. I'm using a language that is both universal and uniquely mine."

Skating Party
Oil on panel
24 x 24 in., 2019
Collection of the James A.
Michener Art Museum

Robert "Pop Pop" Heath
Oil on panel
38 x 24 in., 2020
Collection of New Hope–
Solebury School District

Robert Schoenberg
Oil on panel
30 x 24 in., 2017
Collection of the University of
Pennsylvania LGBT Center

The Bucks County Playhouse Paintings

"

Growing up in Bucks County I was surrounded by art. It was a major component of the region's identity and part of everyone's life. Even though this was largely an agricultural area we were aware of the many painters, writers, composers, and playwrights who lived near the river. Fine paintings hung in banks, schools, and stores. Names such as Michener, Nakashima, Redfield, and Hammerstein were on everyone's tongue. We read the books, saw the plays, and quite a few of us became painters.

The center of that energy was New Hope, and at the center of New Hope stood the tall white mill with its signature Dutch roof: The Bucks County Playhouse. Nationally famous as a springboard for new plays and future stars, it was a lighthouse overlooking river and town.

—ROBERT BECK

“*The decline of the playhouse was disheartening. When it closed its doors, we were all afraid that this place, so important to the theater arts in our country and to the cultural well-being of the people who live in this region, had become just something wonderful that once happened here.*[158]

—ROBERT BECK

The Bucks County Playhouse is synonymous with the finest summer theater in the country, and from its opening on July 1, 1939, the Playhouse has presented a selection of the best American plays, both before and after they were produced on Broadway, with a remarkable cast of performers, including Robert Redford, Liza Minnelli, and James Earl Jones.

The Playhouse gave New Hope its name, or actually, the building that houses the Playhouse did. In 1790, when the original Prime Hope Mills on the site burned down, the mill was rebuilt as New Hope Mills, and soon the town became New Hope,

Pennsylvania. In the fall of 1938 the last miller retired, and the Broadway orchestrator Don Walker, who had been born in Lambertville and lived in New Hope, led a group in repurposing the mill into a four-hundred-seat theater, with both financial and material support from the surrounding community.

From the moment the Playhouse opened, its success transformed the little river town. Hundreds of people came to the theater nightly, and within two weeks the area had galleries, shops, and restaurants to meet the need. But after three decades of success, the Playhouse started to decline, and by the early 1980s the theater had lost its contract with Actors' Equity Association, the professional actors union.

opposite
Playhouse Construction
Oil on panel
16 x 16 in., 2012
Collection of Kevin and
Sherri Daugherty

below
Playhouse Dress Rehearsal
Oil on panel
12 x 16 in., 2012
Private Collection

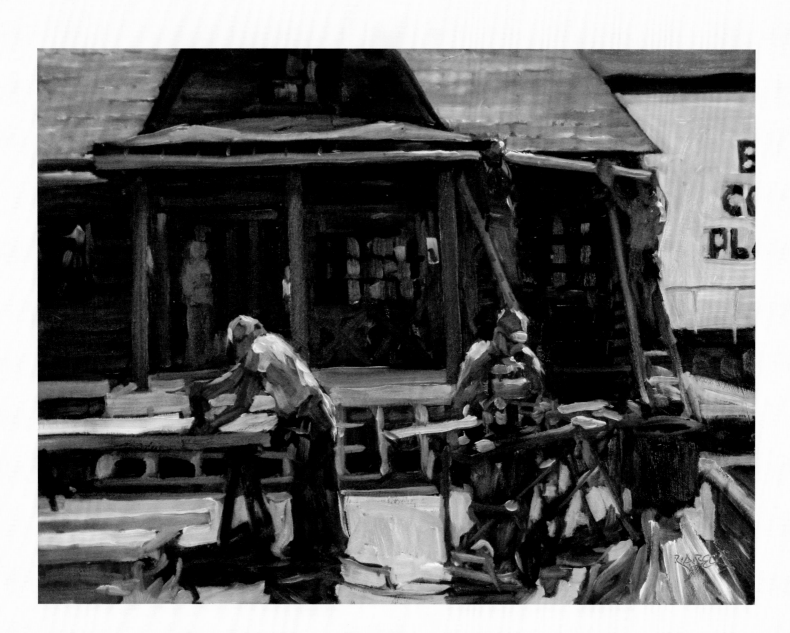

Playhouse Woodworkers
Oil on panel
12 x 16 in., 2012
Private Collection

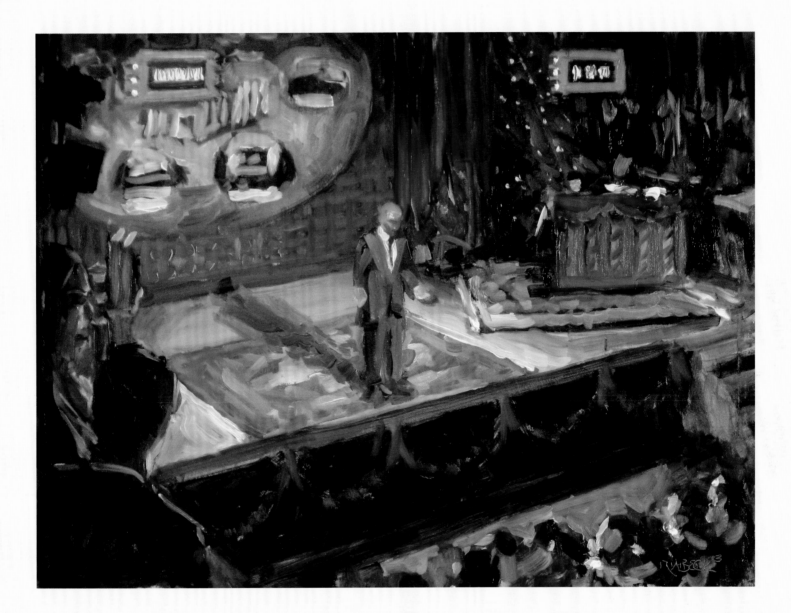

This painting was not part of the original series that Beck painted in 2012. Jed Bernstein was the Broadway producer that helped to revitalize the Playhouse with imaginative productions when it reopened in 2012, including one that transferred to Broadway and was nominated for a Best Play Tony award. He left after two seasons to manage New York's Lincoln Center and Beck painted this work from the Playhouse's balcony during his farewell event.

Playhouse Jed's Farewell
Oil on panel
12 x 16 in., 2013
Collection of Jed Bernstein

Coda:
A Curator's Epilogue

The New Hope art colony was begun by artists who shared an affinity for one another rather than a specific style of painting. Although we traditionally put many of them under the moniker "Pennsylvania Impressionists," they had many different approaches to their work. Edward Redfield's vigorous brushwork in his landscapes is a far cry from the tranquility of Daniel Garber's lush scenes of life along the Delaware, which would never be confused with Robert Spencer's grittier takes of mills and tenements. John Folinsbee's melancholic landscapes may have been influenced by William Lathrop's haunting vistas, but never mistaken for one. Despite their differences, we, as an audience, like categorization, so it is easy to assign one name to these disparate artists.

We do the same for individual artists. We want them to be one kind of *-ist* or another. Robert Beck is a good example. Is he an Impressionist? Realist? Romanticist? What difference does it make when standing in front of one of his paintings? If the work doesn't speak to you, who cares what kind of painter he is. But Beck's work does speak to many, and has for decades, and consequently we want to categorize him.

Stylistically, Beck often uses the darker palette and gestural brushwork that brings to mind Frans Hals, Honoré Daumier, Édouard Manet, and their American counterparts: George Bellows, John Sloan, and Robert Henri. It is Henri's spirit that has a close parallel with Beck. "We are not here to do what has already been done" is something that could have easily come from Beck's lips as Henri's. One can find almost as many resonances with the Pennsylvania Impressionists when looking at Beck's approach and subject matter, as well as his distinctive voice of his energetic painting capturing light and color in the same community.

Rather than try to categorize his work, the question becomes Why does it resonate with so many viewers?

Obviously, there are as many answers to that question as there are people answering it. I believe that besides the quality of his technique, he creates compositions that people can relate to. We can imagine ourselves eating in a bar or restaurant in his paintings, whether we have been in that particular one or not. His work can make your feet feel cold when looking at his painting *Blizzard*. Beck feels that it isn't enough for his subject to be recognizable. He wants to eliminate the details, what he refers to as the "noise" in his paintings, and trigger a recollection of shared experience, "that understanding we all share in common."[161] He wants his viewers to sense a before and after of the subjects in his oils. When he paints people eating breakfast at a diner counter, he wants viewers, as he has often said, "to smell the food and hear the clatter of plates." He wants viewers to truly experience the painting, not simply look at it.

In essence he wants to create a community with viewers, using a shared experience as a bond. In this sense while some artwork is finished with a frame, Beck's paintings seem truly finished only when they are being seen. We expect art that is interactive in this day and age to be a digital push-button affair, but Beck subverts that in his work. By painting scenes from our world today, rather than a traditional pretty picture, he taps into our psyche. Viewers are regularly interacting with his painted panels, bringing their own experience, memories, and emotions to them in ways that seem different from other artists. All artists want their work to connect to their audience, but Beck's efforts look for, and receive, a deeper connection. Particularly in his studio work, Beck often starts with a feeling, or an idea, then he searches for the imagery in his own personal experience that will trigger that feeling in others. He uses a language he describes as both universal and uniquely his own.

He achieves this by his appreciation of human nature, his experience with his tools, and his deft handling of paint. He makes decisions based on whether the color, the imagery, or the gesture take the viewer closer to or further from that feeling he is trying capture. He sees all those elements interacting, so a move in one spot will result in a change somewhere else. For him they aren't questions of technique,

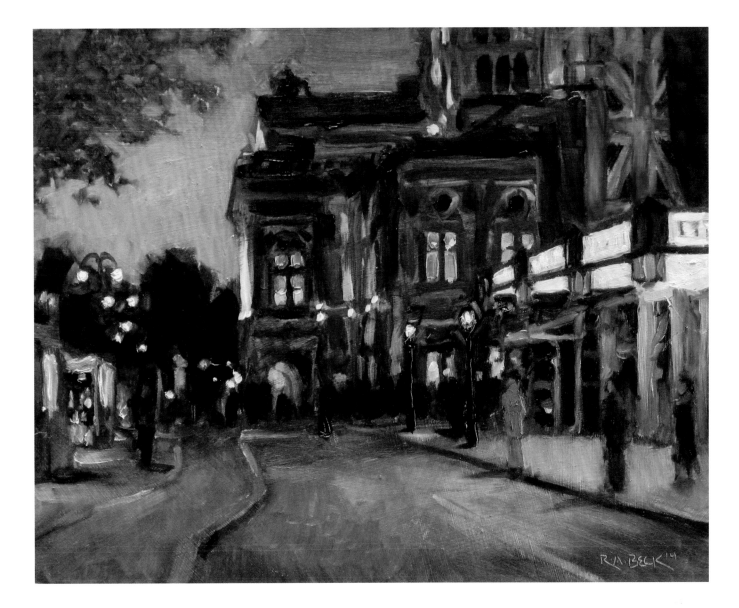

Vienna Opera House
Oil on panel
8 x 10 in., 2014
Collection of
Doreen Wright

they are relationships. No matter
how local his subject may be, his art
is universal, built on common expe-
rience. He's not trying to describe
a thing, he's describing an encoun-
ter, in paint rather than words. Viewers relate to his work
because they have been there, or somewhere like that. His
paintings take them to that common understanding.

That combination of understanding, experience, and
talent is, to me, the gestalt of his work and what makes it
timeless. Don't get me wrong, his paintings of events are
accurate documents of our time, but if he had been born one
hundred years earlier—or for that matter one hundred years
later—his paintings would be of different subjects, but the
intent would be the same. What is clear from his evolu-
tion as an artist is that he has remained true to that intent
throughout his career.

Judging success in art in an empirical world can be
difficult. Popular paintings aren't always good paintings.
Certainly Beck has been successful in the dollars-and-cents
world, and he has had countless articles written about him
and his work and exhibitions in both the United States and
Europe. He has won numerous awards, both big and small,
and honored by a number of organizations for his artwork.
Yet I think the true measure of his success is how his com-
munity has responded to his work. For many in this area,
Robert Beck's paintings are as much a part of their world
as Redfield, Garber, and Lathrop's were to their time and
community. As much as Bellows, Henri, and Sloan were to
theirs. Fifty or one hundred years from now, when scholars
or laypeople want to know about the art of our time in this
storied region, they will turn to Robert Beck's paintings to
get a real sense of who we are, what we did, and, even from
that distance, how it felt. I am willing to predict that by
looking at Beck's paintings, they will understand.

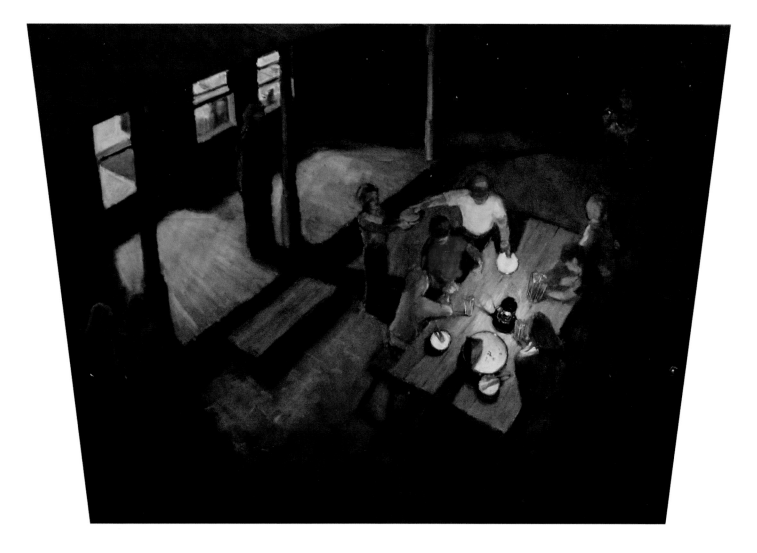

Story
Oil on panel
30 x 40 in. trapezoid, 2014
Collection of Schrock-Taylor

"Western perspective is a convention, not the way we really see things," Beck wrote about his unusually shaped painting. "In the third point of three-point perspective, vertical lines intersect below (or above) the subject in the same manner the other two points extend to the sides. I had been experimenting with shapes of my paintings, but mostly related to the image's composition. In *Story*, the vertical sides of the painting were angled to converge near the location of that third vanishing point, to accentuate the viewer's "perspective." The trapezoidal image isn't missing anything by not having those two lower corners."

Plates

Recent Arrival
Acrylic on panel
48 x 24 in., 1988
Collection of
Dr. Aaron Hasiuk

Princess Longshower
Oil on panel
12 x 8 in., 1998
Collection of Suzanne
Perrault and David Rago

Studio Dog
Oil on panel
24 x 30 in., 1997
Collection of Robert A. Norman
and Liza Fisher

Beck spent a somewhat terrifying evening painting
this scene from life. Every time the grandfather
clock's chime toned, Beck jumped.

Still Life with Flowers
Oil on panel
16 x 20 in., 1998
Collection of Edward and
Susan Murphy

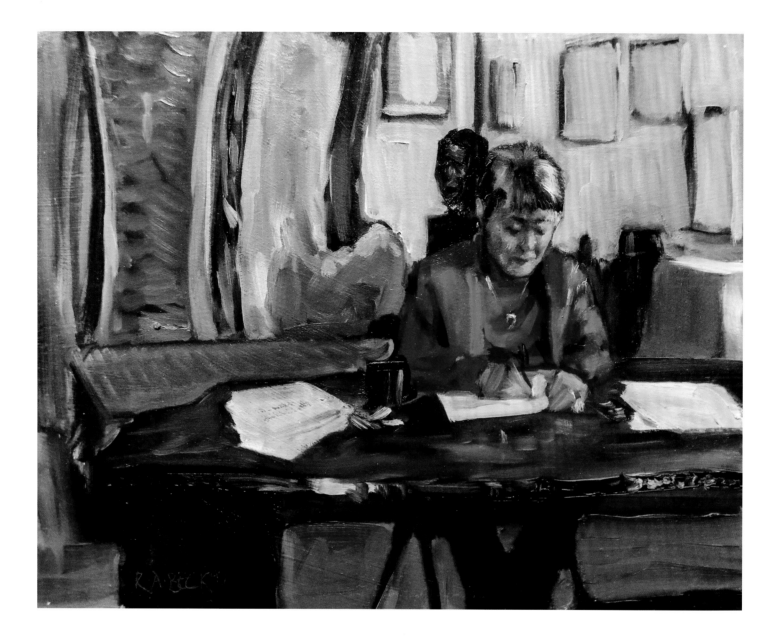

Mira Nakashima
Oil on panel
8 x 10 in., 1999
Private Collection

In many ways, Beck and photographer Jack Rosen
shared a similar relationship to the New Hope–
Lambertville area. They both created their own
personal portrait of the area in their work. Rosen
referred to Beck as a "point and shoot painter."
Both artists challenged themselves to find unique
compositions and experiences.

Jack Rosen
Oil on panel
10 x 8 in., 1999
Private Collection

Owen Luck
Oil on panel
10 x 8 in., 1999
Private Collection

Robert Whitley
Oil on panel
20 x 28 in., 2000
Collection of
The Whitley Family

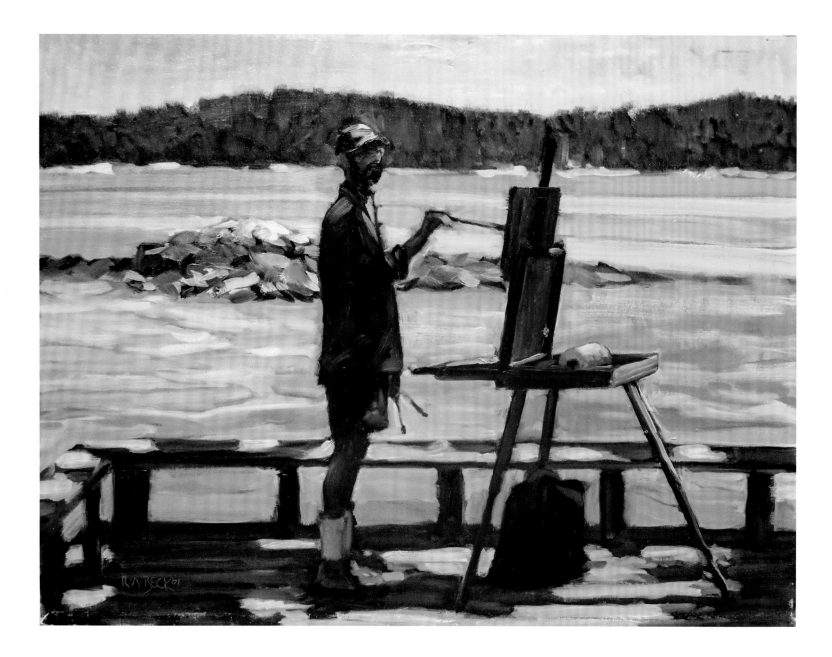

Self Portrait Deer Isle
Oil on panel
12 x 16 in., 2001
Collection of the artist

Engine Room
Oil on panel
12 x 16 in., 2002
Private Collection

Stockton Inn at Night
Oil on panel
10 x 16 in., 2002
Collection of
Jefferson and Laura Barnes

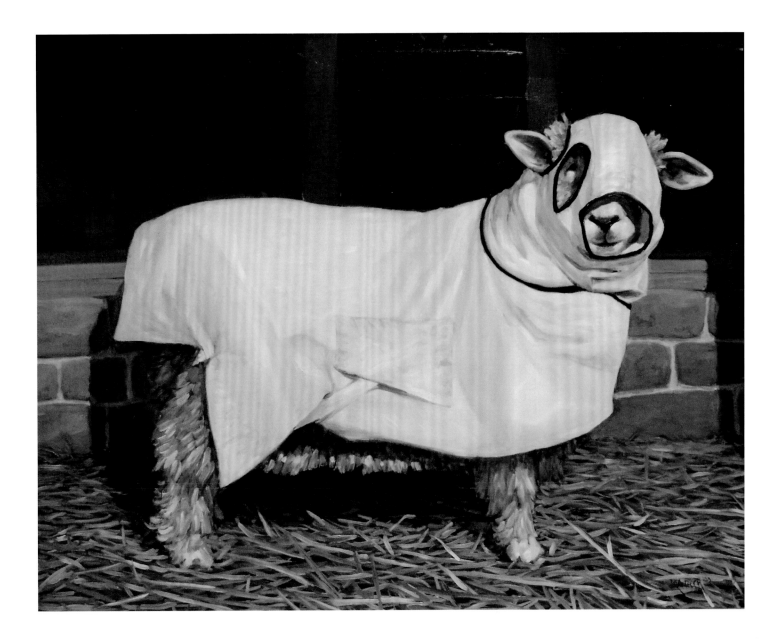

Sheep's Clothing
Oil on panel
24 x 30 in., 2003
Collection of the artist

"The inspiration for *Sheep's Clothing* was a barn at the Grange Fair, which was full of sheep and goats that had been washed, groomed and powdered for the day's judging events. They were fit with robes and hoods to keep them clean. There was no ignoring the resemblance to images of Klan rallies—a common reaction to the painting, given the comments of people who have seen it. The sheep added to the allusion. I'm not neutral on white supremacy. I cocked the hood and ears because I didn't want to dignify the suggestion. The painting depicts a sheep in a robe before judging, and I relied on people relating to it as I did at first encounter to make more out of it than just that."

Over the past two decades this painting has appeared in numerous exhibitions and has continually been in the public eye—including being on Beck's business card for years—before he "retired" the painting to a prominent wall in his home.

Love's Notions and Novelties
Oil on panel
24 x 30 in., 2004
Private Collection

Chateau Exoitque
Oil on panel
12 x 8 in., 2004
Collection of Kit Riley

Nude Sleep Hands
Oil on panel
10 x 10 in., 2004
Collection of the artist

Red Headband (Tension)
Oil on panel
16 x 20 in., 2005
Collection of Annie McNaron

Dupont Circle
Oil on panel
16 x 20 in., 2002
Collection of Doreen Wright

Lewis Island Flood
Oil on panel
10 x 16 in., 2004
Private Collection

Avignon Morning
Oil on panel
12 x 16 in., 2005
Collection of Doreen Wright

Café la nuit, le matin
Oil on panel
12 x 16 in., 2005
Collection of Cindy and
Al Ruenes

First Trap
Oil on panel
16 x 20 in., 2014
Private Collection

Hippocampus
Oil on panel
24 x 30 in., 2013
Collection of Annie and
Barry Ridings

Entourage
Oil on panel
30 x 48 in., 2005
Collection of Cindy
and Al Ruenes

Mad Hatter
Oil on panel
12 x 16 in., 2008
Collection of Mark Pettegrow
and Jim Witek

Once Beck had established himself, he understood his responsibility as a community member. He discovered one way to contribute was to paint a fund-raiser while it took place, and at the event the painting would be auctioned for the cause. It played to his strengths, as he knew from his documentary paintings he could produce a fine work in three hours and could do so despite all the distractions a public event would offer. He has supported many area organizations this way from FACT New Hope (for which *Mad Hatter* was painted) to the Michener Art Museum.

143

**Wroclaw Philharmonic
Performance**
Oil on panel
12 x 16 in., 2005
Private Collection

To support the Riverside Symphonia, a well-regarded professional regional orchestra serving the Delaware Valley for over twenty-five years, Beck was provided access to the orchestra's rehearsals and performances to paint a series of works that were later auctioned off to support the non-profit. These works call to mind the French Impressionists, as well as Ashcan artist Everett Shinn's paintings of various performances, yet bear Beck's distinctive stamp.

Baumaniere Kitchen
Oil on panel
12 x 16 in., 2005
Private Collection

Fencing Academy
Oil on panel
12 x 16 in., 2005
Collection of Mark Holbrow
and Lisa Martini

Irish Night
Oil on panel
12 x 16 in., 2006
Collection of Chris and
Brian Cahill

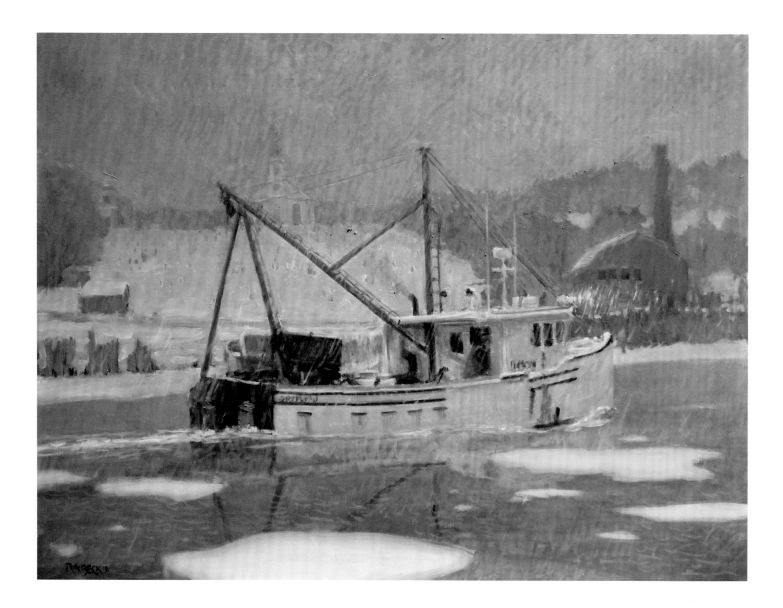

Winter's Return
Oil on panel
24 x 30 in., 2018
Private Collection

Lobster Boil (Large)
Oil on canvas
30 x 30 in., 2011
Collection of Suzanne
Perrault and David Rago

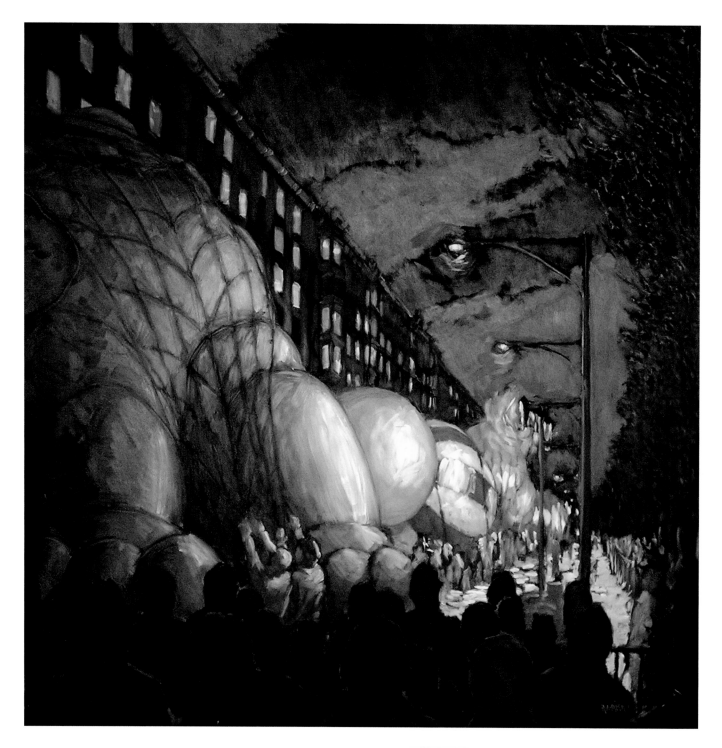

above
Ascension
Oil on panel
40 x 40 in., 2007
Collection of Peter and
Carolyn Gabbe

Underpainting for *Ascension*
Oil on panel
40 x 40 in., 2007

Skating (Central Park)
Oil on panel
12 x 16 in., 2008
Private Collection

Moonlight on York Road
Oil on panel
14 x 14 in., 2017
Collection of
Lucinda Avery Ayers

Welsh's Closed
Oil on panel
12 x 22 in., 2007
Collection of James
and Susan Wells

Tightrope
Oil on panel
44 x 44 in., 2009
Collection of Kevin and
Sherri Daugherty

Bareback
Oil on panel
10 x 16 in., 2009
Collection of Patrick McNeil

Side Door, DeAnna's
Oil on panel
9 x 12 in., 2009
Collection of David R. Gross

Janet Marsh Hunt was the director of Lambertville's Coryell Gallery, which showcased both historic and contemporary artists for more than thirty years. A beloved figure in the local art scene, she also hosted the Lambertville Historical Society's annual juried art exhibition, *Lambertville and the Surrounding Area,* from 1981 to 2013 at her gallery. Each year Hunt chose a recognized artist as the juror, and the exhibition drew artists from all over. When she retired in 2014, Beck hosted that year's show at the Gallery of Robert Beck, then located at 204 Union Street in Lambertville.

Coryell Gallery
Oil on panel
12 x 16 in., 2010
Collection of Barbara
and David Stoller

Crushed Tomatoes
Oil on panel
8 x 12 in., 2010
Private Collection

Giordano's
Oil on panel
size in., 2011
Collection of Dr. Neil
and Dana Cohen

Prairie Dresses
Oil on panel
10 x 10 in., 2010
Private Collection

These two paintings were painted on the same day in 2010. Beck had first visited the Costume Barn, located in Pipersville, and saw the dresses out to dry later in the day and decided to paint those as well.

Costume Barn
Oil on panel
16 x 16 in., 2010
Collection of
Lucinda Avery Ayers

16th & Carpenter
Oil on panel
12 x 16 in., 2011
Collection of
W. Russell G. Byers Jr.

**Christian Street,
Philadelphia**
Oil on panel
8 x 8 in., 2011
Private Collection

Inquirer Lobby
Oil on panel
16 x 16 in., 2011
Collection of Laurada Byers

Sphinx
Oil on panel
16 x 16 in., 2011
University of Pennsylvania
Museum of Archaeology and
Anthropology

Fire (Centerbridge)
Oil on panel
36 x 36 in., 2011
Collection of Barbara and
Steve Diamond

Like Beck's painting *Second Crossing,* this work
was his own response to Edward Redfield's epic
painting, *The Burning of Center Bridge,* which
Redfield painted from notes made the night
the bridge was struck by lightning in 1923. Beck,
who like Redifeld lives near the bridge, used
Redifeld's painting as part of his historical research
to recreate the event in his painting.

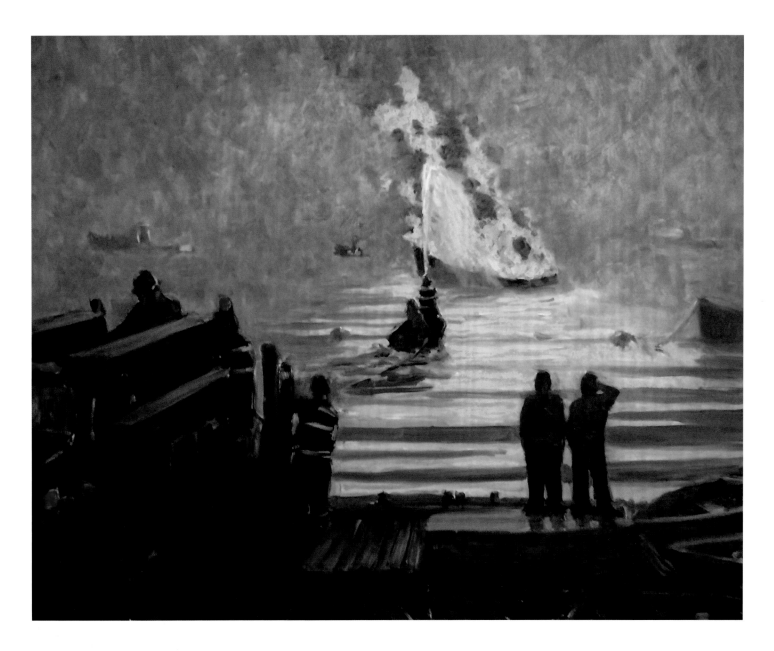

above
Boat Fire
Oil on Panel
24 x 32 in., 2016
Private Collection

Underpainting for *Boat Fire*
Oil on panel
24 x 32 in., 2016
Private Collection

Bodine's Farm
Oil on panel
16 x 22 in., 2012
Collection of Lori Michelin

Stalk Cutting
Oil on panel
24 x 30 in., 2013
Collection of Francis Ferraro

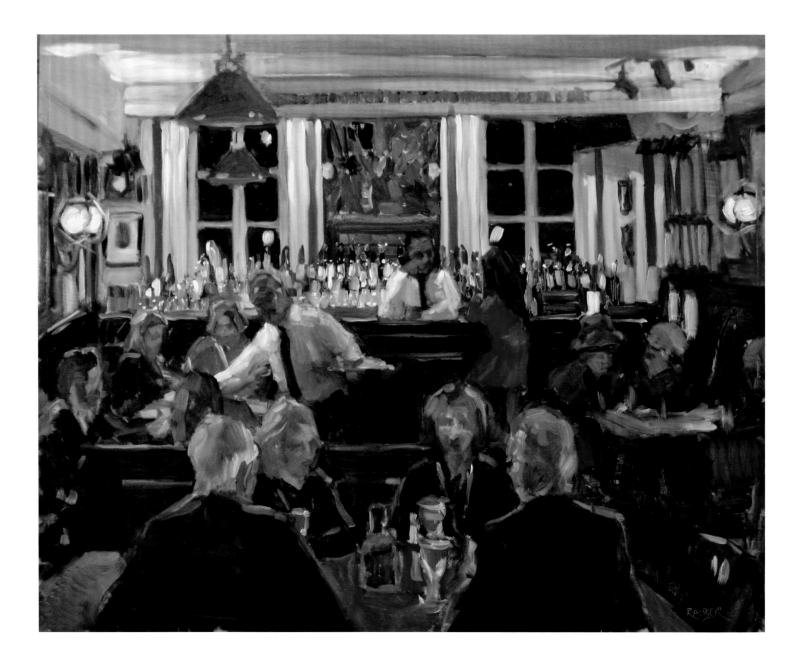

Players Club Bar
Oil on panel
16 x 20 in., 2012
Collection of Jim and
Amie Smith

Eric's Night
Oil on panel
12 x 12 in., 2012
Private Collection

Upper York Road
Oil on panel
8 x 8 in., 2012
Collection of Doreen Wright

Rose and Her Twins
Oil on panel
24 x 30 in., 2013
Collection of Bill and
Pat Patterson

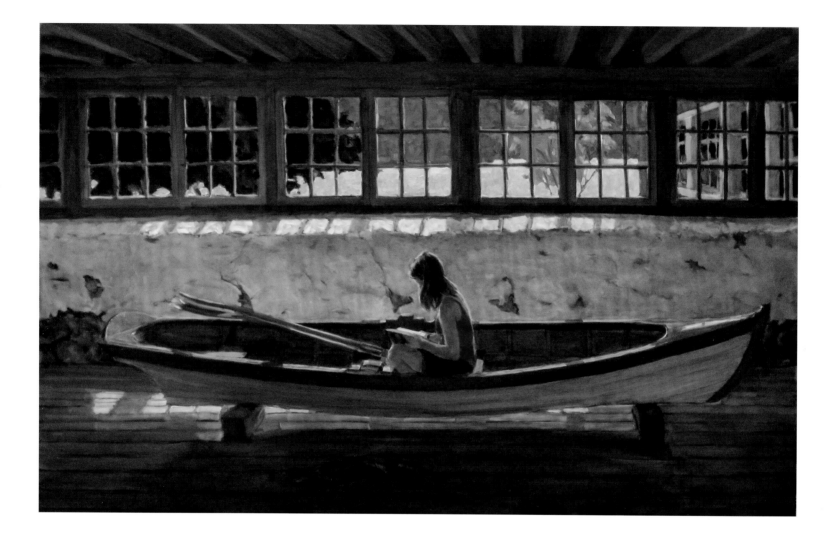

Moby Dick
Oil on panel
24 x 40 in., 2012
Collection of David and
Jacqueline Griffith

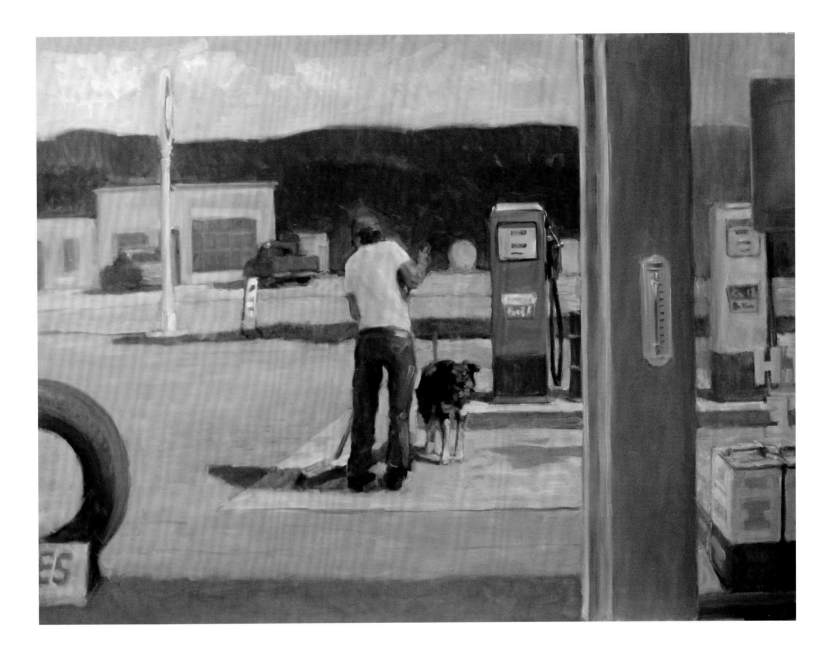

Dog Day
Oil on panel
24 x 30 in., 2012
Collection of
Richard Marfuggi and
Andrew Ruffo

Condiments
Oil on panel
14 x 12 in., 2012
Private Collection

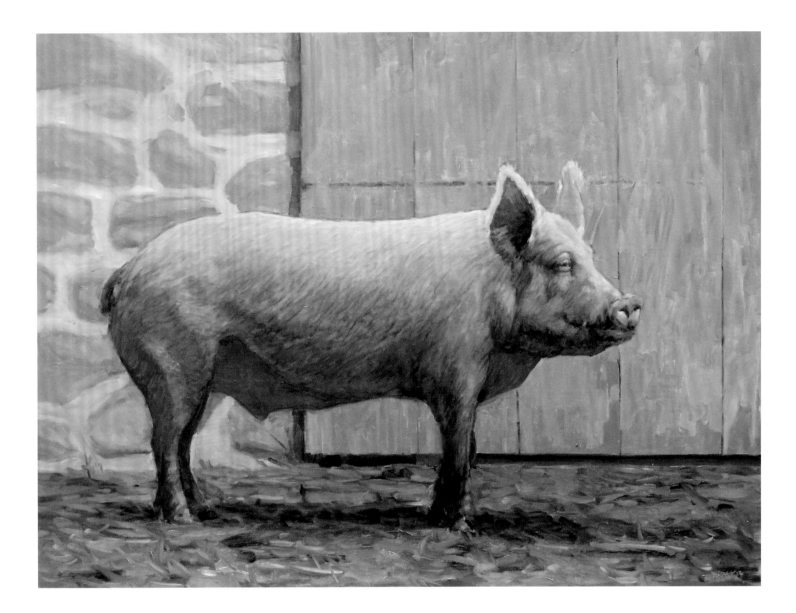

Schnitzel
Oil on panel
24 x 30 in., 2018
Private Collection

Main Street
Oil on panel
12 x 16 in., 2013
Collection of Downeast
Institute (Marine Science
Field Station, University of
Maine at Machias)

Halloween
Oil on panel
30 x 40 in., 2013
Collection of Taylor-Schrock

Ghent Detail
Oil on panel
8 x 10 in., 2013
Private Collection

Coffee House (Vienna)
Oil on panel
24 x 30 in., 2014
Collection of Doreen Wright

Scrum
Oil on panel
10 x 20 in., 2013
Collection of C. Wright

Baptism
Oil on panel
48 x 60 in., 2016–2018
Collection of Kevin and
Sherri Daugherty

Umbrellas
Oil on panel
20 x 28 in., 2013
Private Collection

Broadway Night
Oil on panel
24 x 24 in., 2014
Collection of Chris and
Carol Koyste

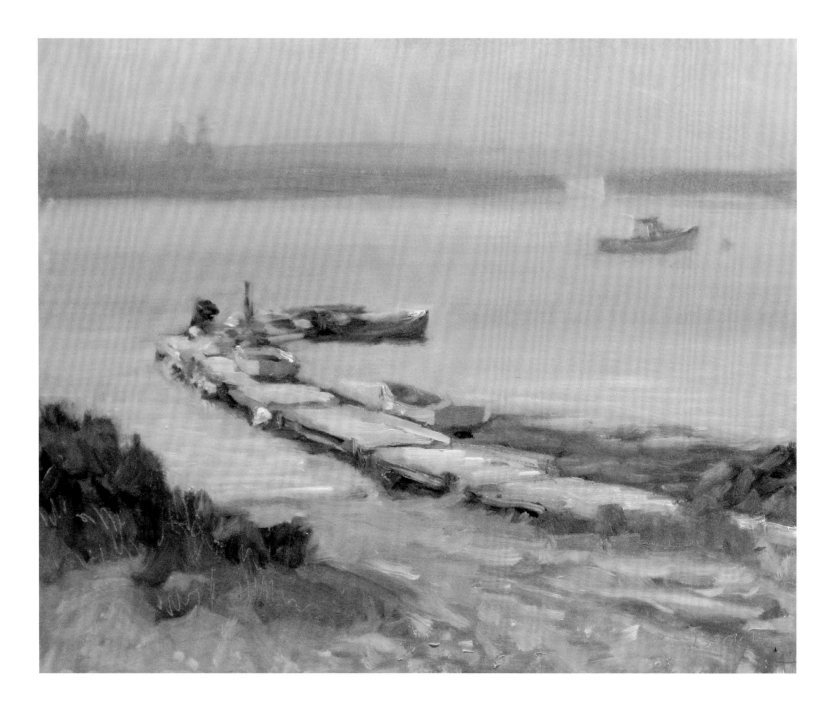

Sune's Dock
Oil on panel
8 x 10 in., 2014
Collection of the artist

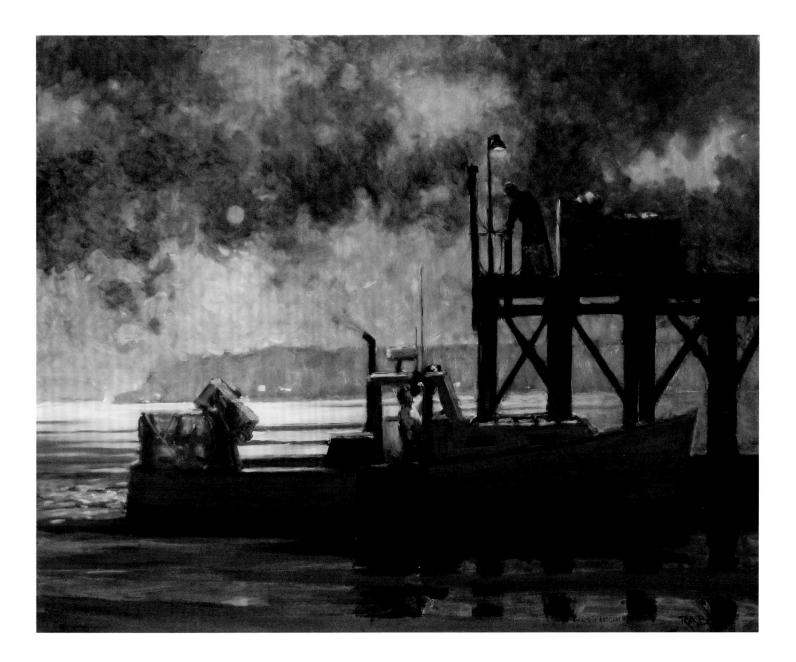

Late Start
Oil on panel
24 x 30 in., 2015
Collection of Margaret
and Will Hearst

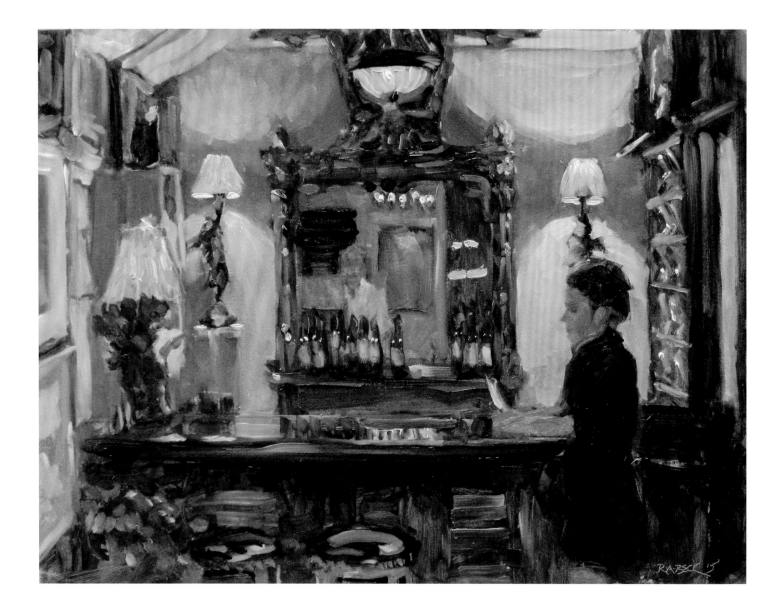

Service Bar (Aileen)
Oil on panel
12 x 16 in., 2015
Collection of
Dawn Robin Miller

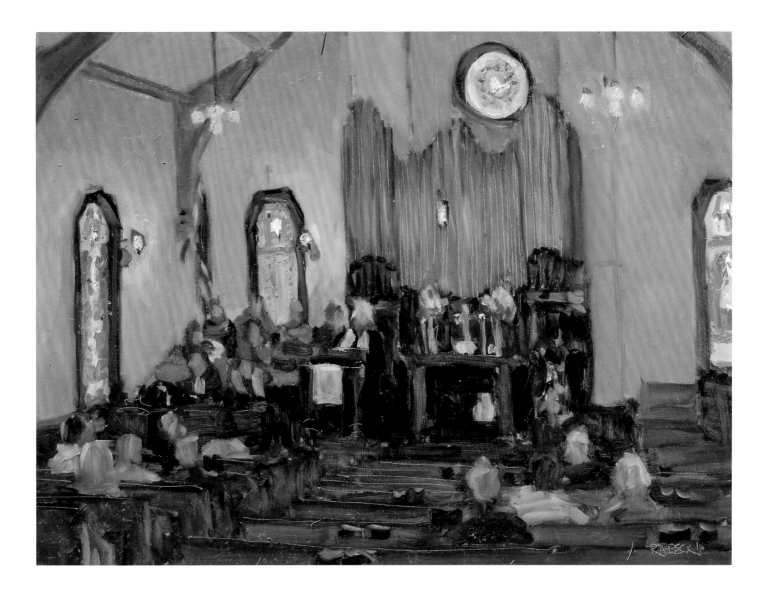

Church Service
Oil on panel
12 x 16 in., 2016
Collection of Downeast
Institute (Marine Science
Field Station, University of
Maine at Machias)

Seeding Clams
Oil on panel
12 x 16 in., 2017
Courtesy of Morpeth
Contemporary

Off Great Wass
Oil on panel
24 x 32 in., 2016
Collection of Joe and
Mary Alice Smith

Heading Home Wismer Road
Oil on panel
24 x 24 in., 2016
Collection of Dr. and
Mrs. Anthony Pineno

Cold Pond
Oil on panel
16 x 21 in., 2017
Collection of Kira and
David Barrett

**Historian (interior from the
Osborne Series)**
Oil on panel
16 x 20 in., 2017
Collection of Doreen Wright

Dante
Oil on panel
8 x 10 in., 2017
Collection of
Patricia J. Singer

above
Tomorrow's Bait
Oil on panel
24 x 24 in., 2015
Collection of Maine Maritime
Museum. Gift of the Wright
Family Trust

Underpainting for
Tomorrow's Bait
Oil on panel
24 x 24 in., 2015

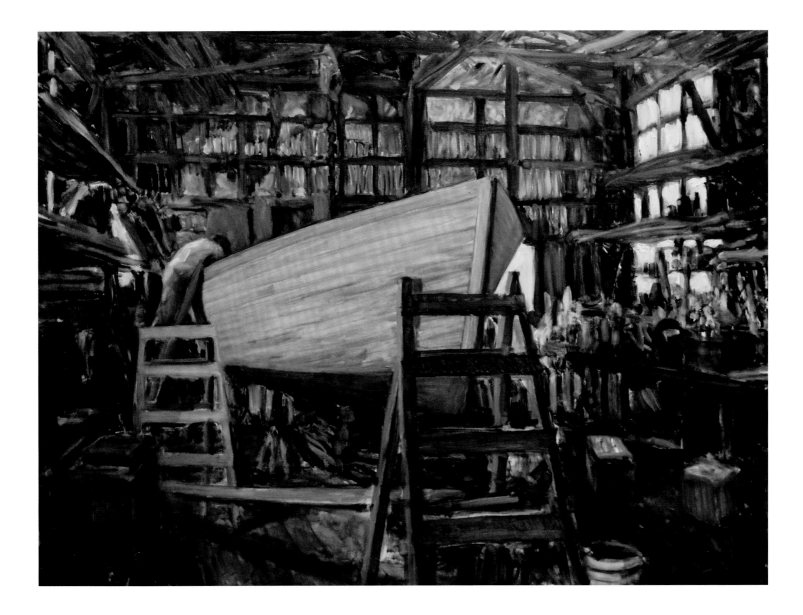

Doug's Boat
Oil on panel
18 x 24 in., 2019
Courtesy of Morpeth
Contemporary

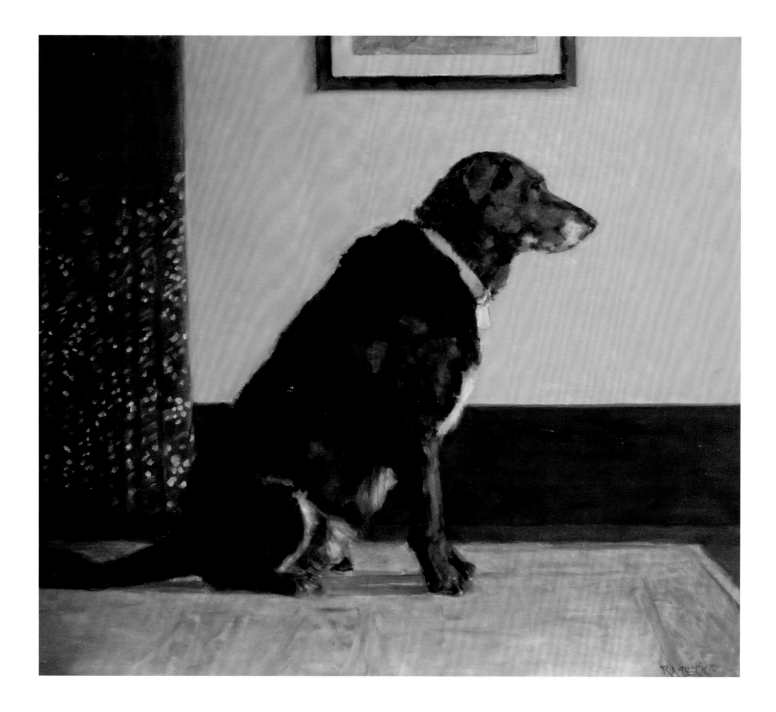

Whistler's Dog
Oil on panel
24 x 24 in., 2018
Collection of Doreen Wright

Beck has long been fond of dogs and has had a canine companion for most of his life. Dogs pop up in his writing and in his paintings. His dog Jack, a Labrador mix, was kind enough to sit for this portrait, echoing James McNeill Whistler's famous painting of his mother.

Grilled Cheese (detail)
Oil on panel
8 x 8 in., 2019
Collection of the artist

Solstice (Fireflies, Goat Hill)
Oil on panel
20 x 28 in., 2018
Collection of Suzanne
Perrault and David Rago

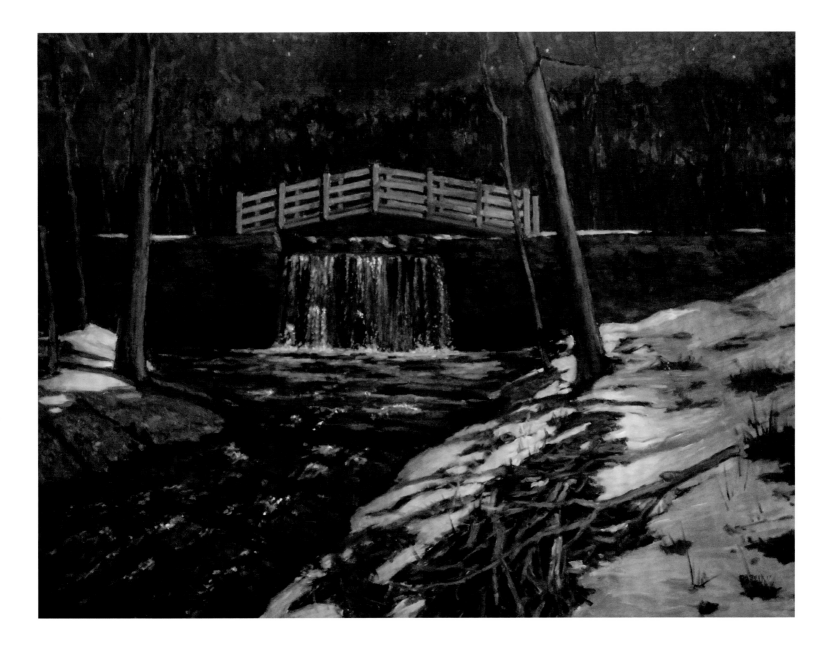

Night Music
Oil on panel
30 x 40 in., 2017
Collection of Kira and
David Barrett

Raising
Oil on panel
72 x 96 in., 2012
Collection of Delaware
Valley University

Beck was inspired by the murals of Thomas Hart Benton to create this panoramic work. Throughout his career, Beck has referred to a barn raising as the ultimate community event. Here he uses it as metaphor for the passage of time and the promise of tomorrow, as the vehicles evolve from horse drawn carriages to contemporary automobiles, as do the tools that the workers use. On the far right, a white man and a black woman plan for the future. The boy in the center foreground is Beck himself.

Ice Storm (Bodine's Farm)
Oil on panel
16 x 20 in., 2019
Courtesy of Morpeth
Contemporary

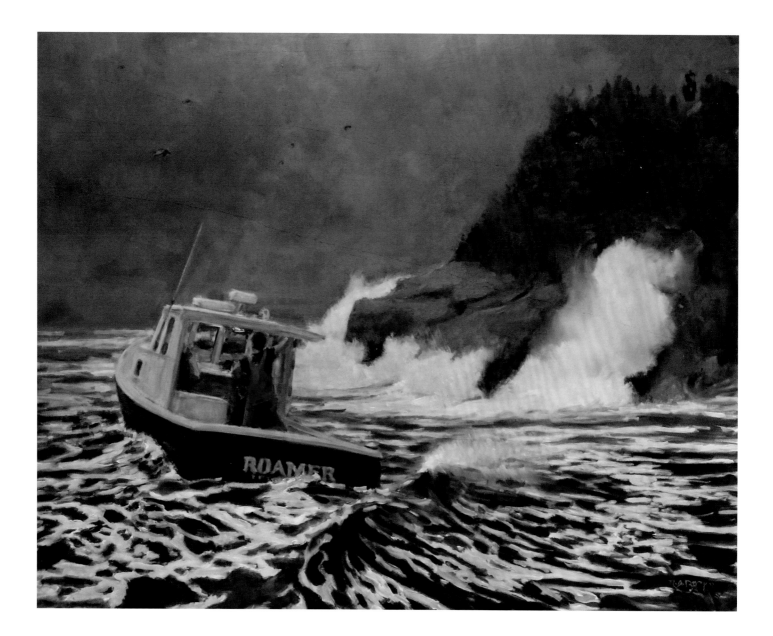

Narrows
Oil on panel
20 x 28 in., 2019
Courtesy of Morpeth
Contemporary

Some of Beck's Maine paintings are larger panels
created in his studio, based on the plein air works
he had done in the Pine Tree State, so that Jonesport
stays with him even when he is back in Pennsylvania.
Although he typically works exclusively on his
panel from start to finish, for *Stormtide* (opposite)
he made two small preparatory studies in which he
mapped out the composition and colors of the final
work, giving viewers the rare opportunity to see
how the artist constructs a painting.

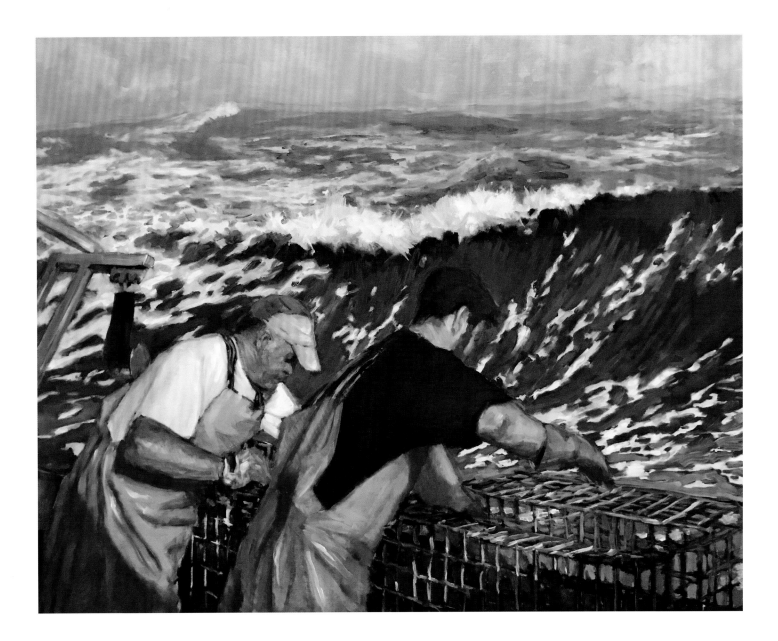

above
Stormtide
Oil on panel
24 x 30 in., 2020
Collection of the artist

Preliminary Study for
Stormtide
Oil on panel
4 x 5 in., 2020
Collection of the artist

Preliminary Study for
Stormtide
Pencil on paper
4 x 4 in., 2020
Collection of the artist

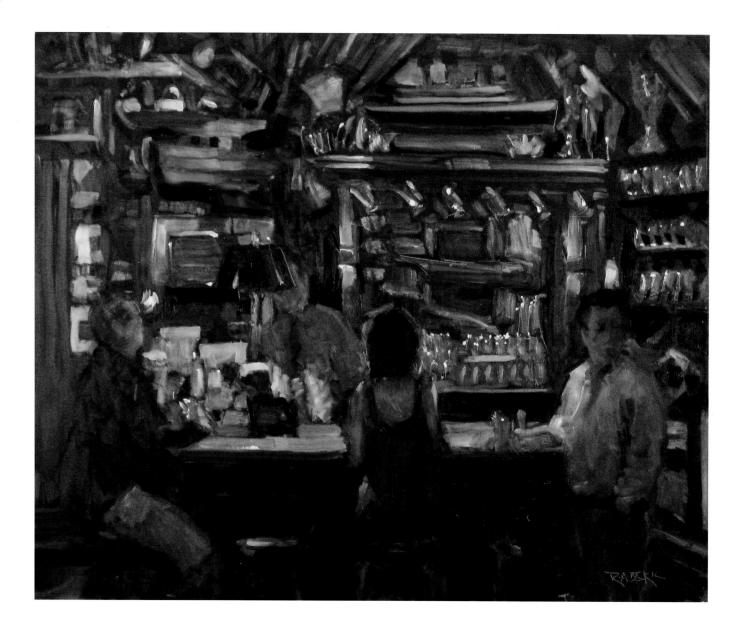

Boat House
Oil on panel
12 x 16 in., 2012
Private Collection